HAVERIN

THROUGH TIME

Michael Foley

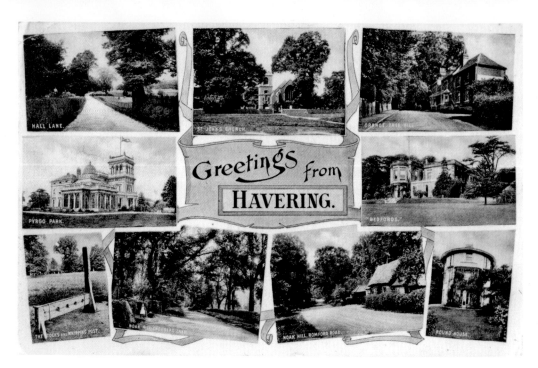

Although Havering is the name of the borough, there is also a village that still retains a rural atmosphere and has the name Havering Atte Bower. Many of the buildings on the card still stand today.

<div align="center">

To
Joe Heller and John Worden.
For help beyond the call of duty.

</div>

The sepia images on pages 5, 6, 9, 33 and 69 are unfortunately of low quality, but have been included for their historical interest and relevance.

First published 2010

Amberley Publishing Plc
Cirencester Road, Chalford,
Stroud, Gloucestershire, GL6 8PE

www.amberley-books.com

Copyright © Michael Foley, 2010

The right of Michael Foley to be identified as the
Author of this work has been asserted in accordance
with the Copyrights, Designs and Patents Act 1988.

ISBN 978 1 4868 892 6

British Library Cataloguing in Publication Data.
A catalogue record for this book is available from
the British Library.

Typeset in 9.5pt on 12pt Celeste.
Typesetting by Amberley Publishing.
Printed in the UK.

Introduction

It was only when I began to prepare this book that I discovered a few things about the London Borough of Havering that I didn't know before. Firstly I realised that despite having lived in the area all my life there were parts of the borough that I had never been to and was, in fact, not even sure where they were. The locations depicted in the old images I have collected were in many cases unknown to me and it often took some time to find them.

Secondly I had not realised, despite being in the places quite often, how much the area I had known as a child has changed. It was only when I went to look at these seemingly familiar sites that I discovered the original buildings and places were, in most cases, no longer there.

The town of Romford is a perfect example of this. During the 1960s and 1970s much of what was considered old Romford vanished. The ring road that has been built around the town has had a devastating effect on many of the towns' old sites – Laurie Square disappeared altogether. Traffic that had once moved through the market no longer does and the High Street has been as good as cut in half.

I also realised, interestingly, that most of the old buildings that have survived seem to be public houses. I'm not sure if that says anything about the population of Havering. Perhaps it does, as some of the other old buildings that survive are now nightclubs.

Whatever the reasons for the changes in Havering, a book like this one is important as it shows how things have evolved, not only for those who remember how Havering Borough used to

look, but also for those who don't. How our world used to look is important to us all.

I have had some help in producing this book and would like to thank; Simon Donoghue of the Havering Local Studies Library for finding and allowing me to use some of their images; The staff at Swan Books for pointing me in the right direction to find a road that didn't seem to exist; and the people I accosted on the streets when trying to find the sites of buildings that had disappeared.

Michael Foley- www.authorsites.co.uk/michaelfoley

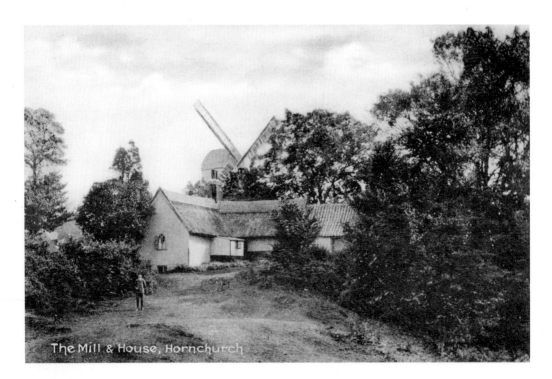

The Mill & House, Hornchurch

The Mill
The mill at Hornchurch dated back hundreds of years until it closed just before the First World War and burned down just after. The Mill Field was used for sporting events, as was the nearby Dell. One of these sports was prize fighting. The Mill House has survived although the view of it is now obscured by an electricity sub station and the undergrowth in the nearby field.

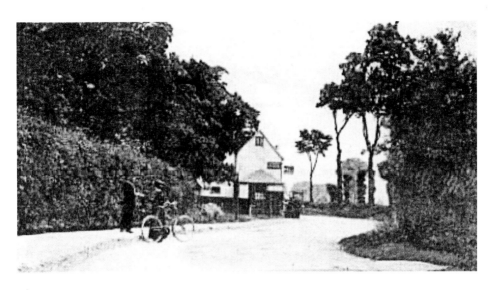

Collier Row

The Bell Inn stood in Collier Row Lane before the area began to be developed, and the lady to the left of the photograph shows a popular form of transport from the early twentieth century when cycling was fashionable amongst all classes of society. The modern view – looking towards Havering Atte Bower – shows how different Collier Row is today, with its large shopping centre and modern estates.

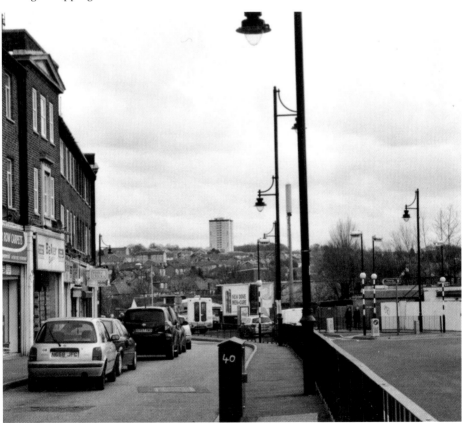

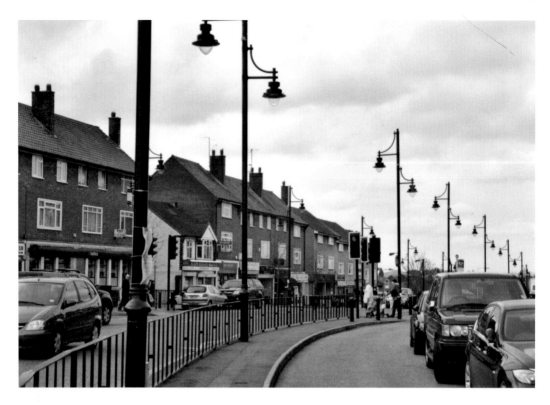

Collier Row

The positioning of a lady with a bicycle seems to be a popular theme in old photographs of Collier Row. The few houses shown in this early photograph must date to the early part of the last century, although they were probably built before this. Since the 1920s Collier Row has been developed with Romford spreading northwards. Despite this expansion, Collier Row retained its rural atmosphere and, to a certain extent, still does with a great deal of open space within easy reach of its streets.

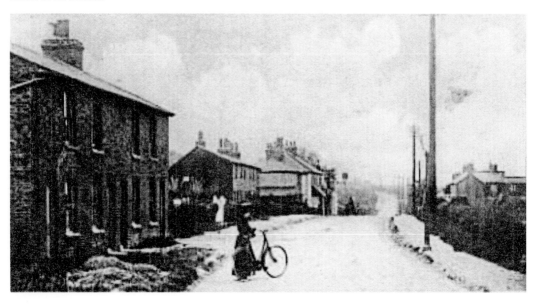

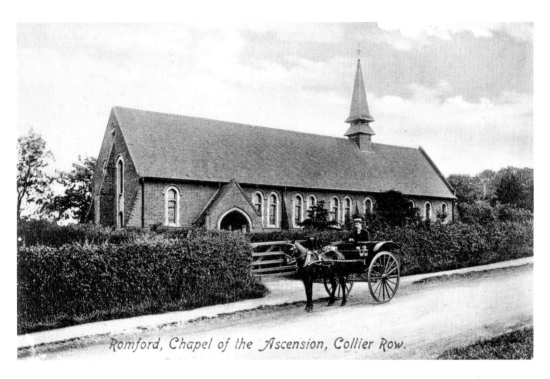

Romford, Chapel of the Ascension, Collier Row.

Collier Row Church

The church in the old photograph is the Chapel of the Ascension. There was originally a mission on the site, which was paid for by a Mr E. Condor. As well as being a chapel it also had a reading room. The present church was built in 1886 and is now the Anglican church of the Ascension.

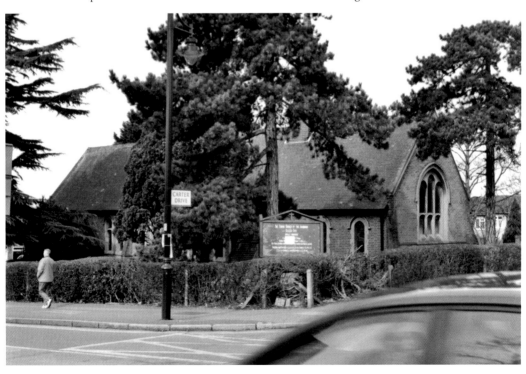

Collier Row Village

The old photograph shows Collier Row as a remote village with a few houses along the Lane from the church. Today it is a very different place with both sides of what is now a busy road built up. There are very few old houses, and probably none surviving from the time of the old photograph.

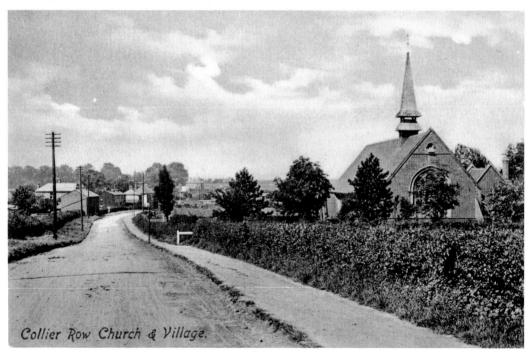

Collier Row Church & Village.

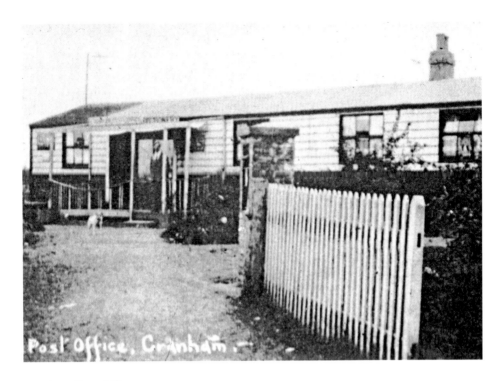

Cranham Post Office

The original post office in Cranham was based in an old army hut. It was situated in the Broadway and after residential use the site was used to build shops in the late 1950s. The post office is now inside the Tesco supermarket on Front Lane, the supermarket itself would not have been dreamed of in the days of the original post office. (Above: *London Borough of Havering Local Studies Library*)

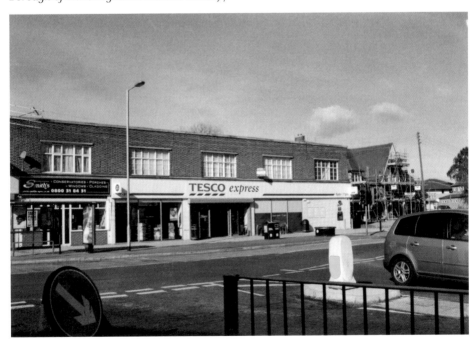

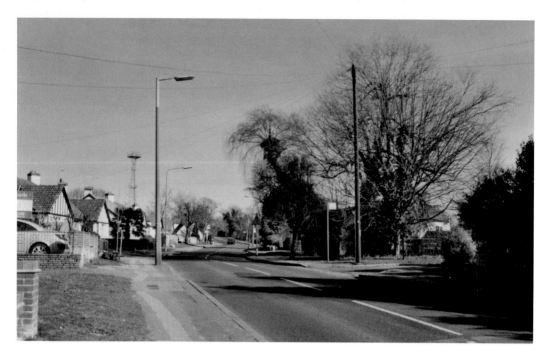

Front Lane Cranham

The old photograph of Front Lane, Cranham, shows the rural atmosphere of the old village. The bridges across the ditch in front of the houses show how undeveloped the area was. The modern Front Lane is very different with a well-made road and modern houses lining both sides. The tall tower in the background shows the position of the railway yard. One remnant of old times is a pond, which is behind the trees to the right of the photograph. (Below: *London Borough of Havering Local Studies Library*)

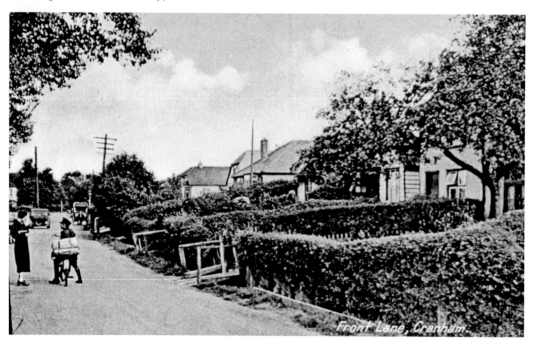

Front Lane, Cranham

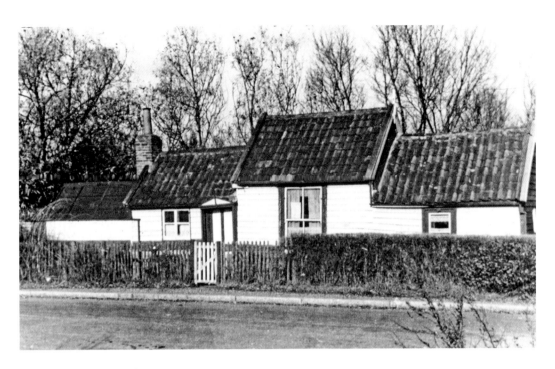

Moor Lane Cranham

This old wooden building would look out of place in the modern Moor Lane. The houses that now line the wider road are all much more modern than this. At the top of Moor Lane where it meets Front Lane there are now a number of shops, although there is still a village feel to the area. (Above: *London Borough of Havering Local Studies Library*)

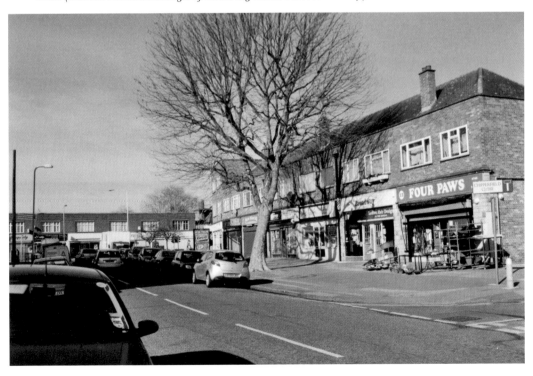

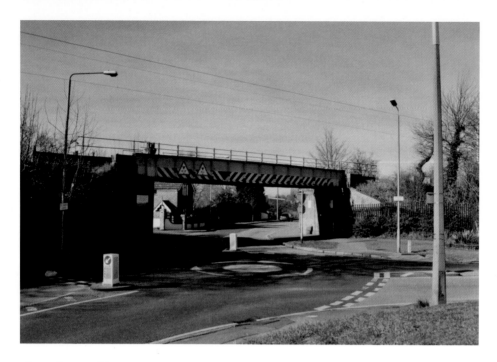

The Railway Bridge Cranham

The railway bridge at the junction of Front Lane with St Mary's Lane does not seem to have changed very much from this early photograph. The posters under the bridge have disappeared and the bus, being a single decker, would have been able to go under the bridge. Today the road on the Front Lane side of the bridge is much busier than it would have been in the time of the first photograph. The St Mary's Lane side of the bridge seems to have changed much less than the Cranham side. (Below: *London Borough of Havering Local Studies Library*)

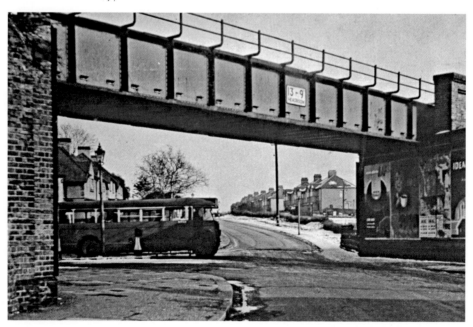

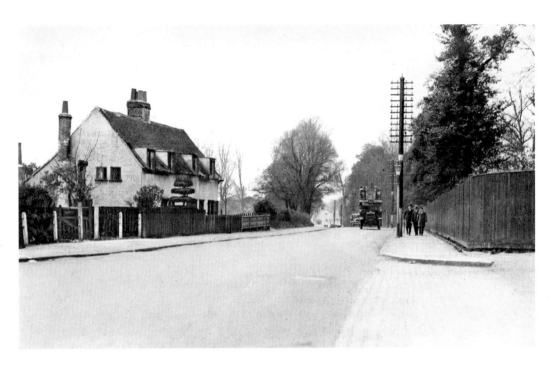

Main Road

This is an interesting old view of Main Road with a very old bus whose journey would no doubt have been into Romford. The road is still very rural and is depicted before the building of the large houses that now line its route. The modern photograph shows Main Road looking towards Romford. Perhaps some of the trees are those from the old photograph but the houses on the left look to date from the 1930s.

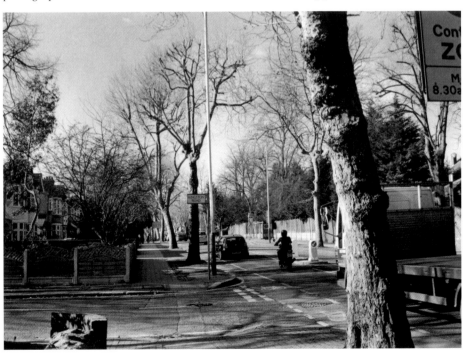

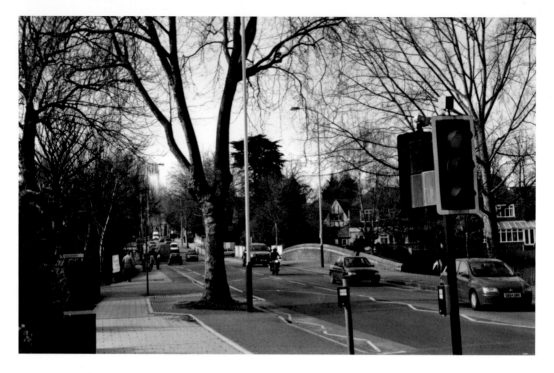

Blacks Bridge Road

Blacks Bridge Road is now part of Main Road. The lake in Raphael Park was once known as Blacks Canal and the bridge over it known as Blacks Bridge. It was named after the unpopular owner of Gidea Hall at the time, Mr Black, a dealer in military equipment who bought the hall in 1802. The bridge is today part of Main Road and the amount of traffic passing over it would have been unimaginable in the days of Blacks Bridge.

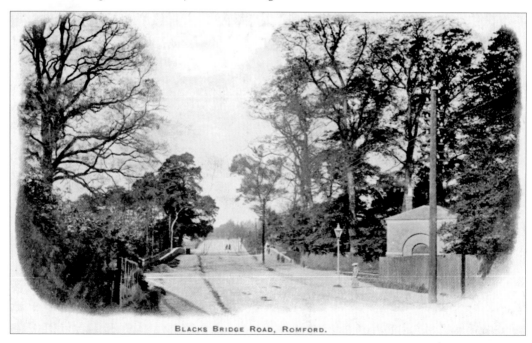

BLACKS BRIDGE ROAD, ROMFORD.

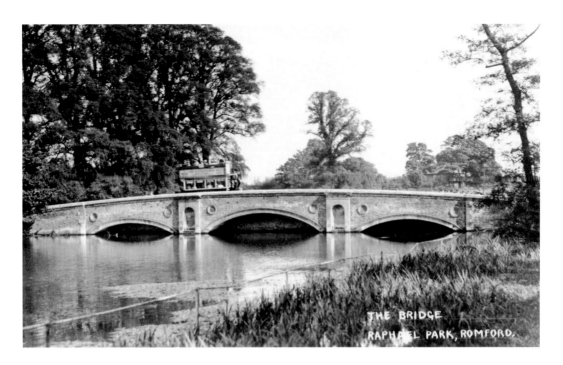

THE BRIDGE
RAPHAEL PARK, ROMFORD.

The Bridge

The view of the bridge from inside Raphael Park shows what a fine structure it is. The old bus passing over it indicates that it has been an important route for some time. The bridge has changed very little as the modern photograph shows, although the position from where the old photograph was taken is now someone's garden.

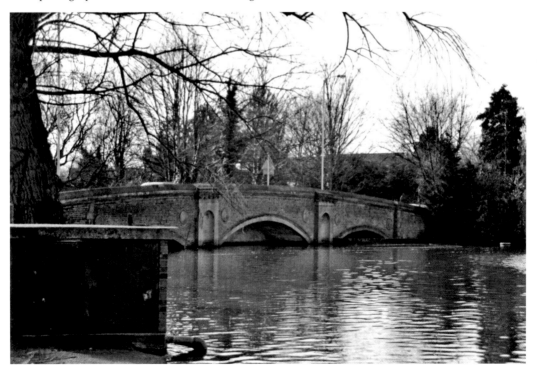

Raphael Park

Raphael Park was presented to the town by the Raphael family who lived at Gidea Hall. It was one of the concessions to the town for allowing the building of the housing estate that now covers the site of the hall's grounds. The entrance to the park has changed little since it was first opened to the public and has been a wonderful boon to the town since.

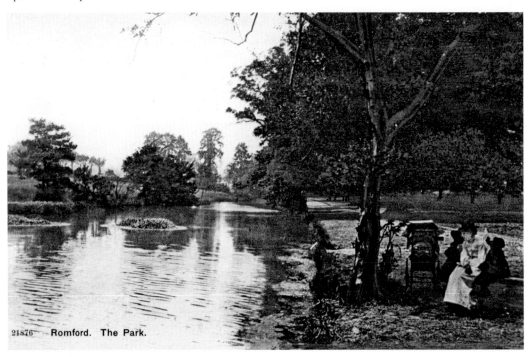

21876　Romford. The Park.

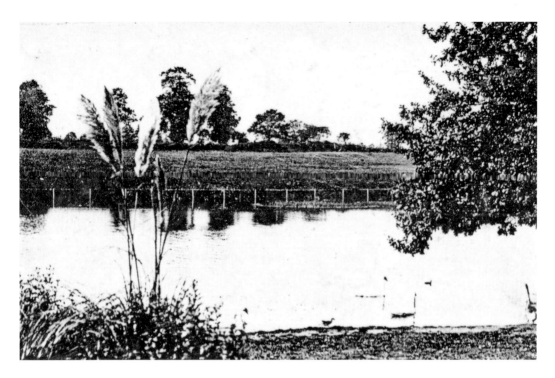

Raphael Park

The view in this early photograph of the lake in Raphael Park differs greatly from the one today. On the far side of the lake there is open land with nothing in site but a few trees. The modern view, however, includes the rear of the houses in Lake Rise. The gardens of these houses run down to the lake with the fountain in the centre of the photograph.

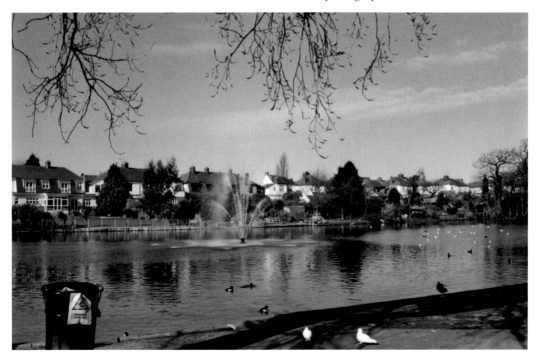

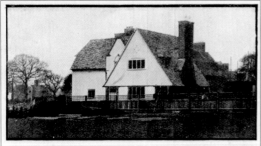

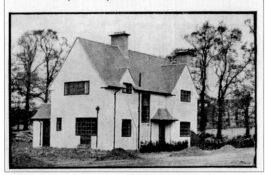

The Romford Garden Suburb
Surrounding Raphael Park is the
Romford Garden Suburb. The older
photograph is from an advertisement
in the *Graphic* newspaper of May 1911.
Sir Herbert Raphael, owner of Gidea
Hall, provided one thousand guineas in
prizes in a competition to design houses
that would cost £350 or £500 – a large
amount in those times. The modern view
shows the area of the Romford Garden
Suburb today.

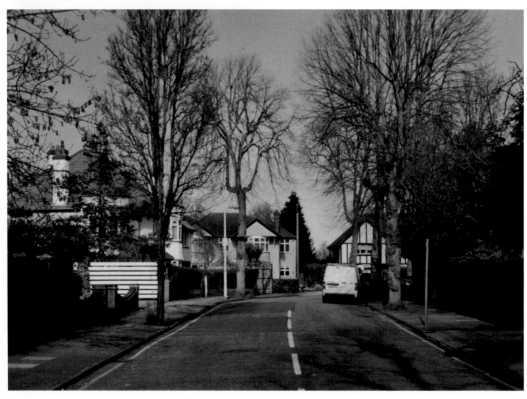

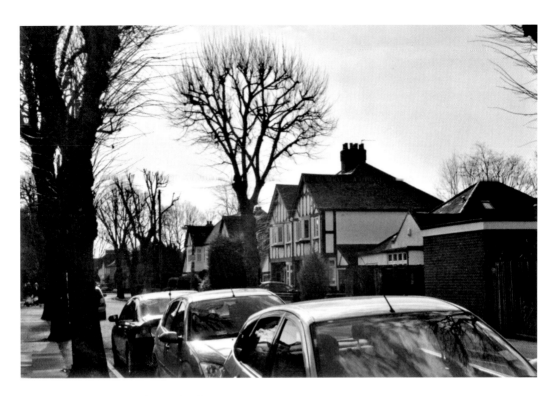

The Romford Garden Suburb

The old view shows the houses of the new Garden Suburb being built on an estate covering about 450 acres. Note the builder's transport is a horse and cart. The houses today have changed little, but the streets around them have and are now full of cars rather than horse and carts.

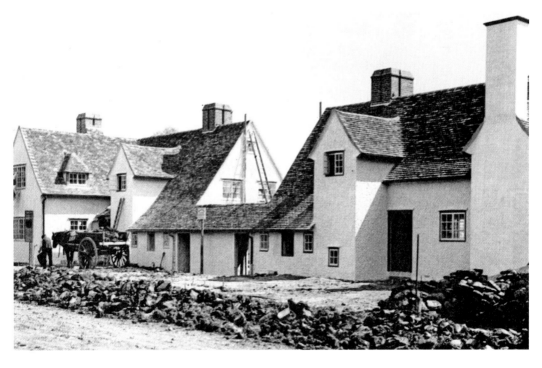

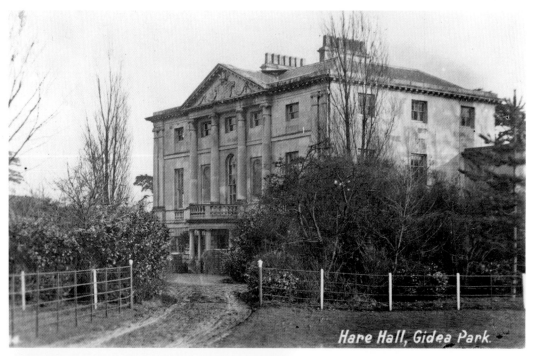

Hare Hall, Gidea Park.

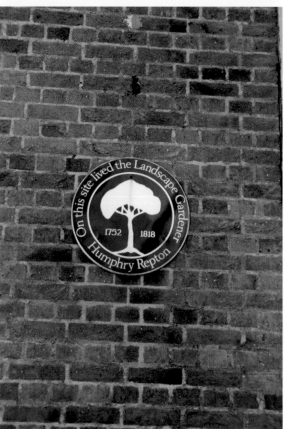

Humphry Repton

Hare Street was a small hamlet on the road from Romford to Colchester. It was home to famous gardener Humphry Repton at the end of the eighteenth and early nineteenth century. He was a friend of John Wallenger who owned nearby Hare Hall and it is believed that he may have done some work on the gardens there. The site of Repton's old cottage is now lost beneath Lloyds Bank, but there is a plaque on the wall of the building commemorating him.

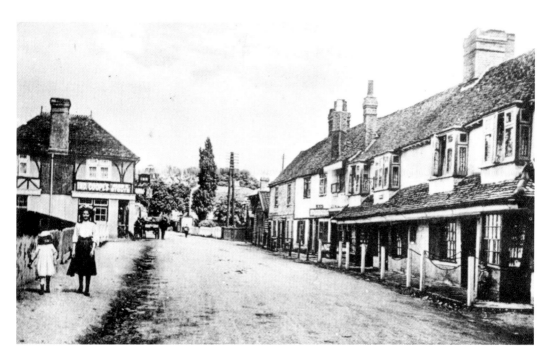

Hare Street

Hare Street was still a rural hamlet until the early twentieth century. It was the beginning of the building of the Romford Garden Suburb in 1911 that changed the area drastically. It is now a modern shopping area, however a number of original buildings survive.

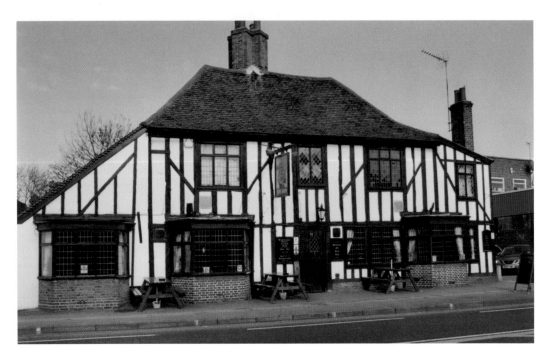

Hare Street

Another view of the old hamlet of Hare Street in its rural days. Although not far from Romford there was a bus service from the early part of the twentieth century, which helped to bring people to the hamlet's country inns. Before this it had been a popular spot with walkers and cyclists. The modern picture shows one of the remaining public houses on Hare Street.

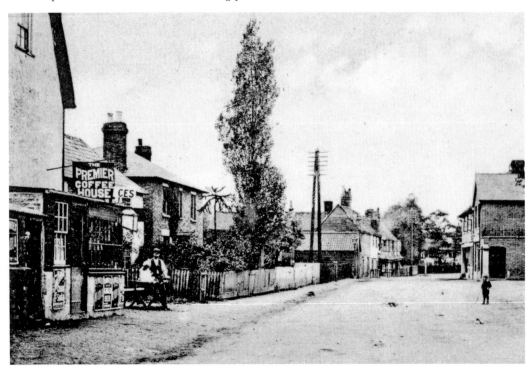

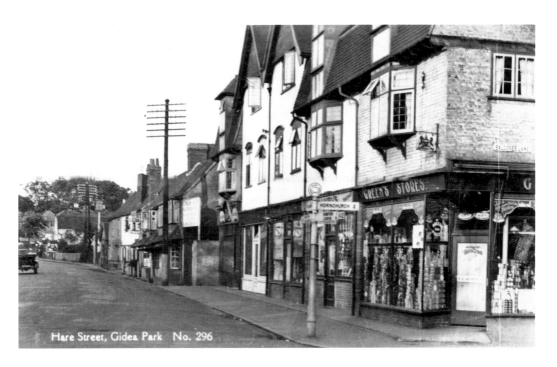

Hare Street, Gidea Park No. 296

Hare Street

A view of Hare Street at the corner of Balgores Lane. The old road sign is visible stating two miles to Hornchurch. The two miles must have passed through some very rural countryside at that time. The buildings on the right look very similar and seem to have changed little in the modern view of the same spot.

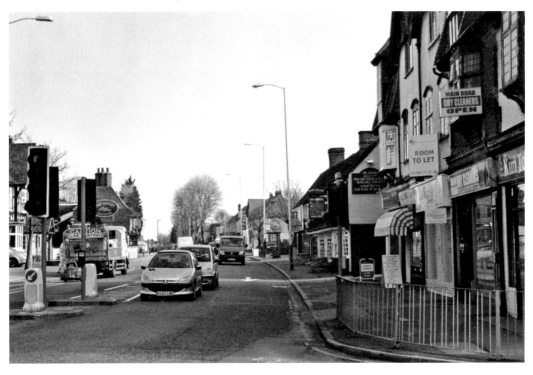

Hare Hall Camp

The area around Hare Street became very well known during the First World War when the grounds of Hare Hall became an army camp. The first unit based there were the 2nd battalion of the Sportsman's. The old photograph shows their officers. The modern photograph of the nursery school in Balgores Lane shows the building that was used as the officer's mess for Hare Hall Camp.

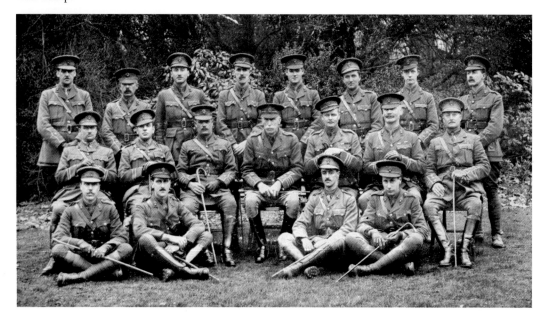

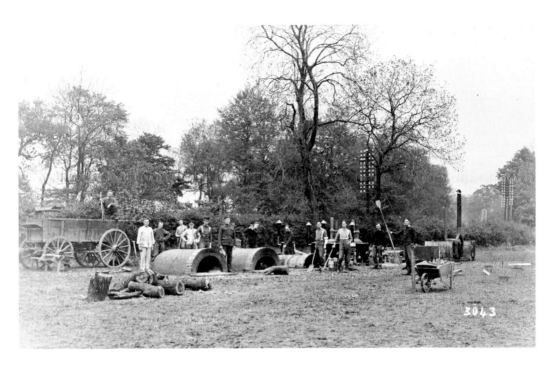

The Military

The open spaces in the area around the camp at Hare Hall were used to train the soldiers based there. The golf course was supposedly used for trench digging training. This old photograph shows mobile kitchen units – the soldiers had to be fed. There are few remaining areas of open space in Gidea Park now, the sports ground near Gallows Corner and the golf course behind it were undoubtedly used by the military.

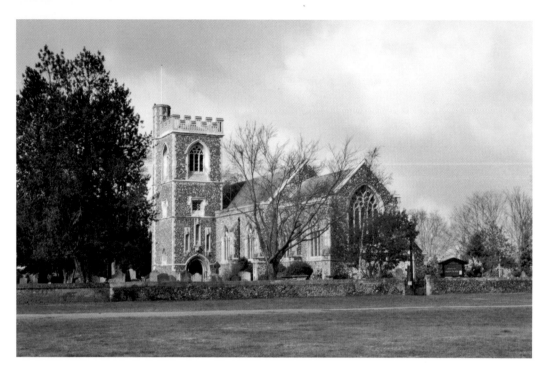

Havering Church

Havering Atte Bower is one of the older and more unaltered parts of Havering. Once the site of a royal palace it has a history of its own. The church of St John the Evangelist stands on the village green and dates from 1875. As can be seen from the modern photograph little has changed since the early twentieth century.

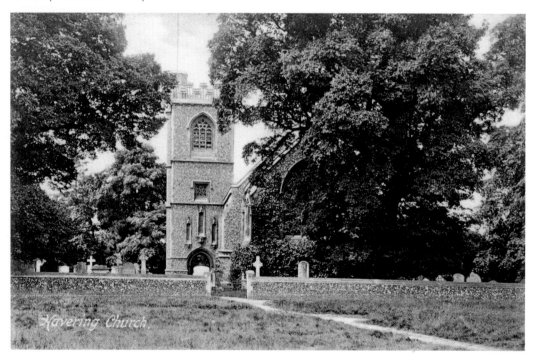

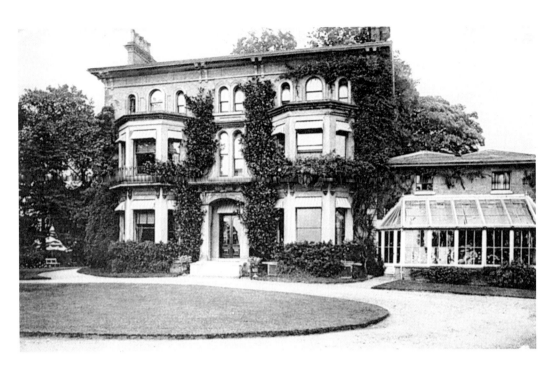

Havering Hall

Havering Hall was built in 1858 and was one of the many large houses in the area. It was owned by a Miss Barnes in the early twentieth century, whose family owned large parts of East London. The modern view of the hall shows how secluded it has become since. It is now used as St Francis Hospice.

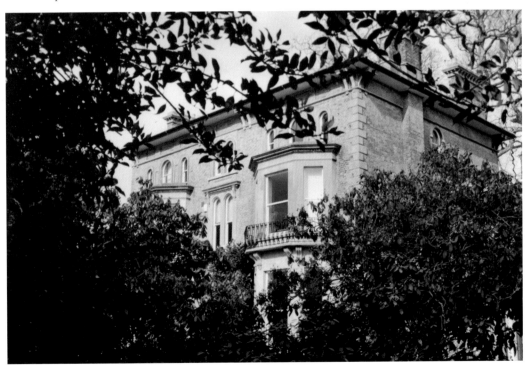

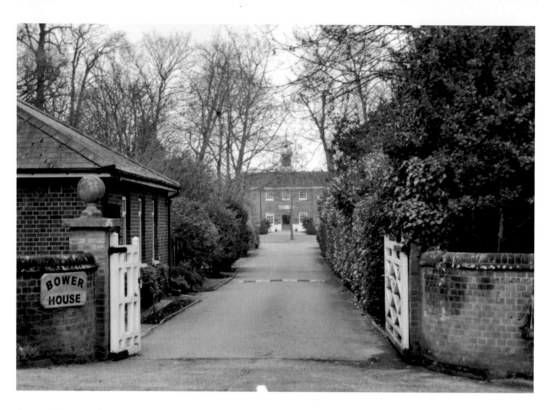

Bower House

The original Bower House was built in 1729 but has been added to over the years. The house was once part of one of the largest estates in Havering. In 1976 it became a conference centre owned by the Ford Motor Company. The entrance is on Orange Tree Hill.

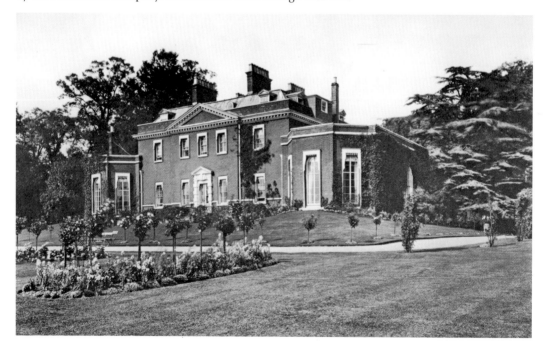

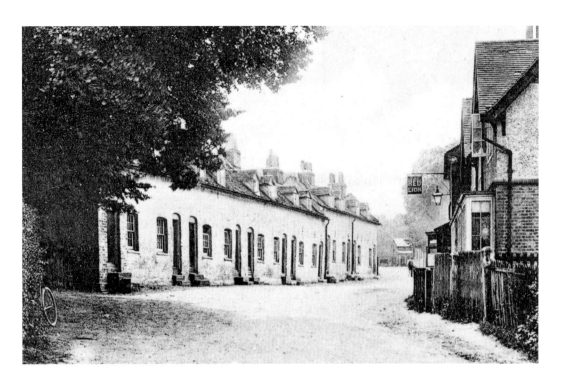

Havering Village

Havering has managed to keep its rural appearance due to the green belt rules that have stopped the building of the new houses that have covered the land between the village and Romford. There is an ancient legend associated with Edward the Confessor and a ring that was returned to him there, which is where the name Havering comes from. As the modern photograph shows little has changed although a few new homes were built in the 1930s.

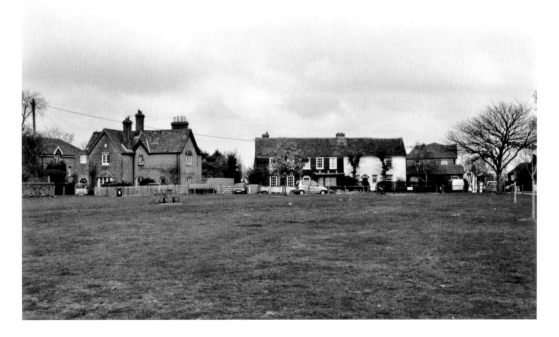

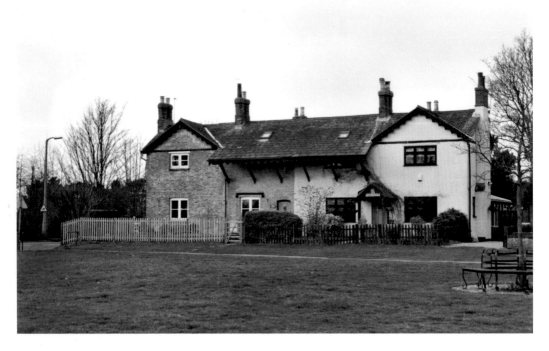

Havering Post Office

The old photograph depicts what was Havering parish room and post office. The building next to it has changed very little, as is often the case in Havering. There is now no post office in the village and only a very infrequent bus route serves the area.

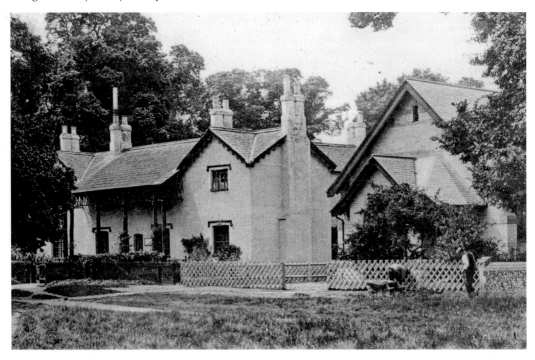

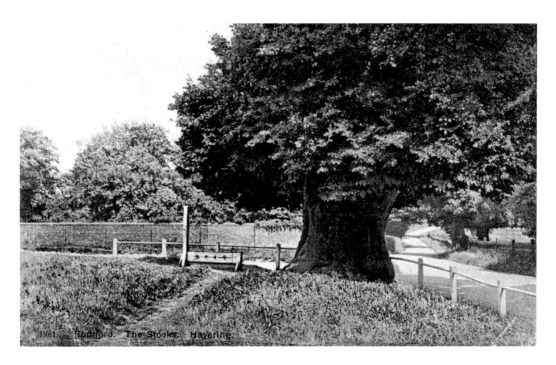

The Stocks

The stocks and whipping post still stand on the village green at Havering. They are not as original as it first seems and today are in fact copies – erected in the mid 1960s. However the old photograph dates from the early twentieth century. Unfortunately when I went to take the photograph they had been removed for repair. It seems that the large tree that was growing next to them has also been removed.

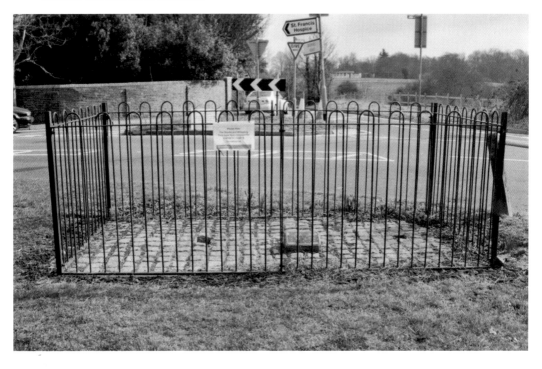

Orange Tree Hill

The old view of Orange Tree Hill depicts a very rural scene. The hill got its name from the Orange Tree Inn that still stands on the site. It is also the location of the oldest building left in Havering. The Blue Boar Hall dates from the seventeenth century and was once an inn, but is now a home. The modern photograph shows that the area is still very rural although there are a number of modern homes on the left side of the hill as you go up it.

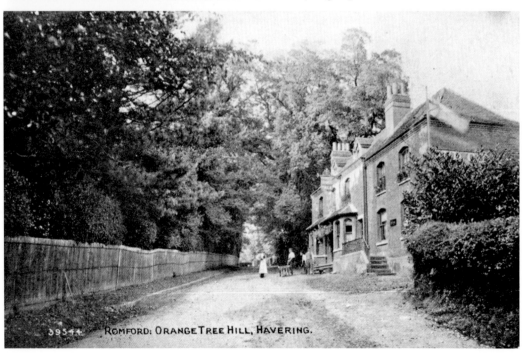

39544 ROMFORD: ORANGE TREE HILL, HAVERING.

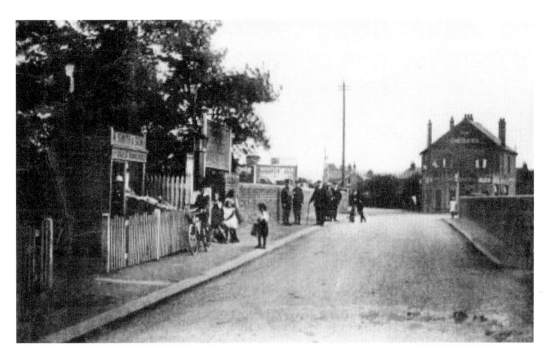

Emerson Park

The station at Emerson Park was opened in 1893 by London, Tilbury and Southend Railway Company. It is on the route from Romford to Upminster. There has been very little change since the railway opened – there are still no buildings at the station just a canopy. The modern photograph is taken from the other side of the bridge and shows the Chequers Public house from the rear. The bridge has changed little over the years and is still quite narrow.

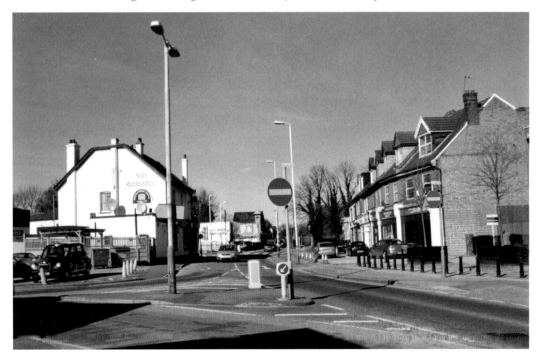

Butts Green Road

The buildings shown in the old photograph are shops that still stand next to the railway bridge at Emerson Park. The shop on the right is the Estates Dairy. The building itself has changed little since the earlier image was taken, but it is now home to a different business.

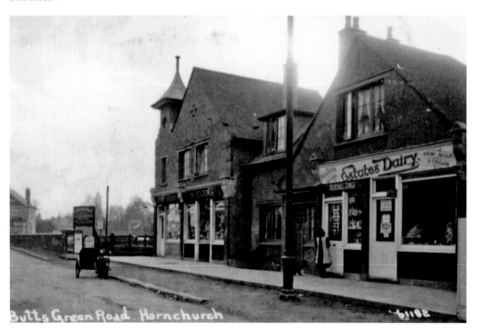

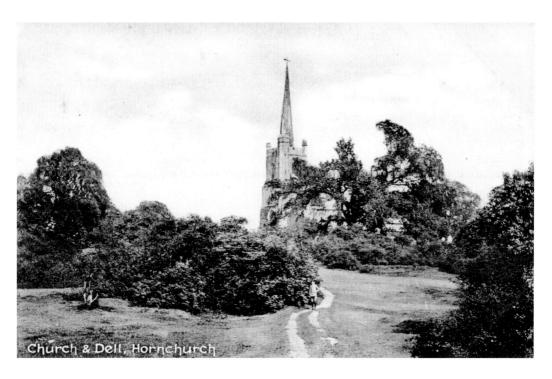

Church & Dell, Hornchurch

The Dell

The Dell was supposedly an old quarry and became a sporting venue. The sport that took place there may not be recognised as such today, as the main event seems to have been cock fighting. The area has now been taken over as a large electricity generating site and the area around it has been allowed to grow wild as can be seen from the modern photograph. The view of the church in the background is mainly obscured.

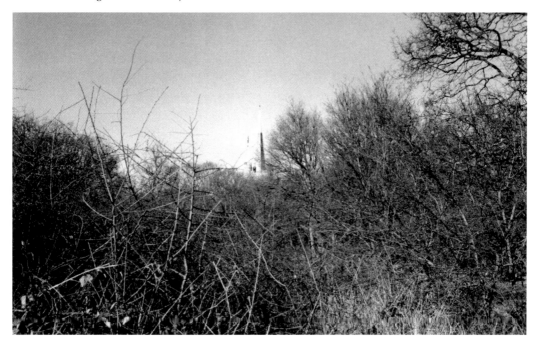

Greytowers Camp

During the First World War Greytowers became an army camp and the grounds were filled with wooden huts for the troops. The house itself was used as officer's quarters. The map shows the layout of the camp. The modern photograph shows the front of what was once Greytowers estate. There is a tree lined open space, behind which there are now allotments.

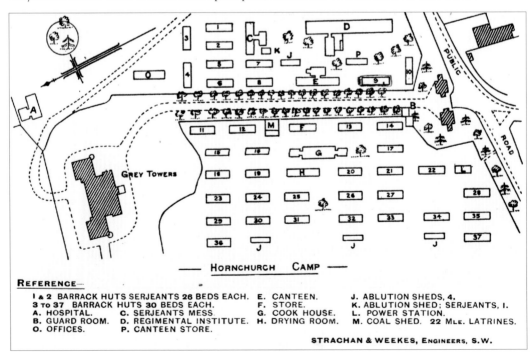

HORNCHURCH CAMP

REFERENCE—

1 & 2 BARRACK HUTS SERJEANTS 26 BEDS EACH. E. CANTEEN. J. ABLUTION SHEDS, 4.
3 TO 37 BARRACK HUTS 30 BEDS EACH. F. STORE. K. ABLUTION SHED; SERJEANTS, 1.
A. HOSPITAL. C. SERJEANTS MESS. G. COOK HOUSE. L. POWER STATION.
B. GUARD ROOM. D. REGIMENTAL INSTITUTE. H. DRYING ROOM. M. COAL SHED. 22 MLE. LATRINES.
O. OFFICES. P. CANTEEN STORE.

STRACHAN & WEEKES, ENGINEERS, S.W.

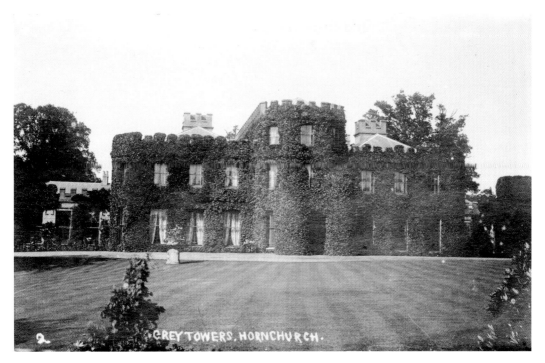

Greytowers

Greytowers House was built by Colonel Holmes in a very similar design to his previous home at Harwood Hall, Corbets Tey. It was built on part of his father-in-laws estate at Langtons. The modern photograph shows the gravestone of Colonel Henry Holmes and his wife in St Andrews churchyard. They both died shortly before the First World War.

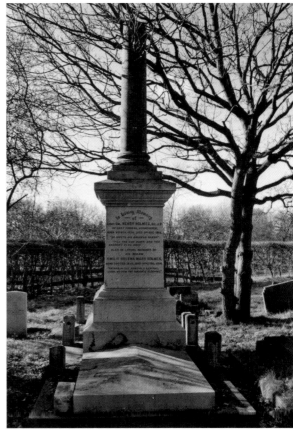

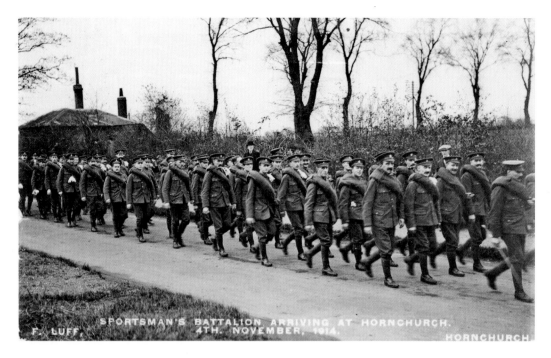

Arrival of the Sportsman's Battalion

The first army unit to arrive at Greytowers camp were the Sportsman's battalion, a special unit made up of celebrities and ex public school boys. Because of their background they were allowed to enlist in the ranks up to the age of forty. When the Sportsman's battalion arrived they were led into the camp by the band of the Hornchurch Cottage Homes. This was a children's home that stood across the road a little farther west of Greytowers. It is now a private housing estate but many of the former buildings still stand. The modern photograph shows part of the estate.

The Sportsman's Battalion at the Gates

The gates to the camp were situated at the top of what is now Greytowers Avenue. There was little secrecy during the First World War as the sign by the gate shows. The battalion forged close links with the town and a club for the soldiers was opened in North Street School. The later photograph shows some of the old buildings in North Street today.

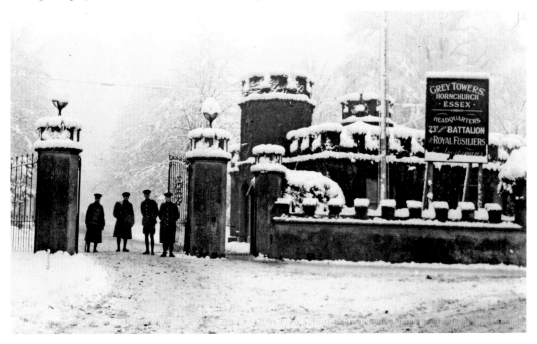

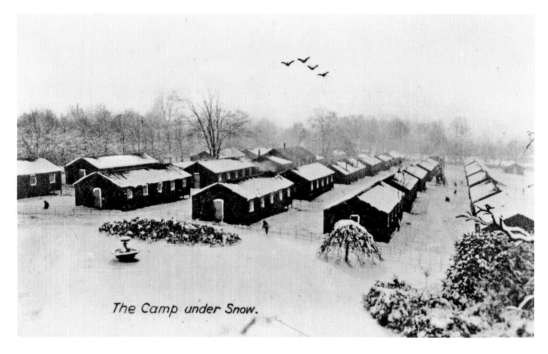

The Camp under Snow.

The Camp Under Snow

The old photograph shows how difficult the conditions must have been for the men in the camp. Although each hut had a heater, living in what were no more than large sheds cannot have been pleasant. However conditions in France were much worse. The modern picture shows the allotments that now cover the site of the camp.

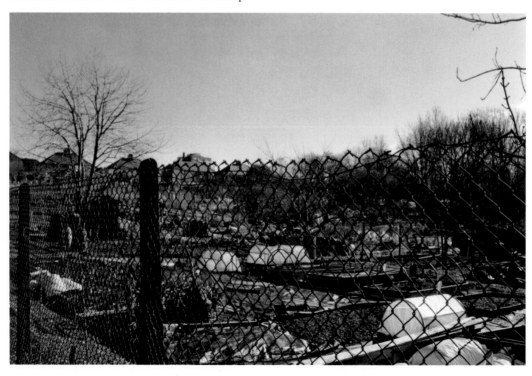

The New Zealanders Camp

Greytowers eventually became a convalescent camp for wounded soldiers from New Zealand. This included some Maoris, a number of which are buried in St Andrews churchyard. The old image shows one of the roads inside the camp. The modern photograph shows Greytowers Avenue today. The road follows the same route that the driveway up to the house previously covered.

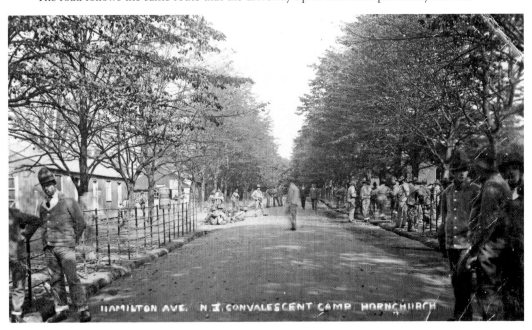

HAMILTON AVE. N.Z. CONVALESCENT CAMP HORNCHURCH

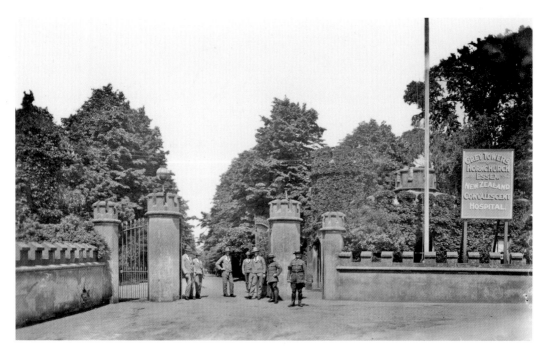

New Zealanders at the Gates

This is almost an exact copy of the photograph of the Sportsman's battalion at the gates, although the sign to the right has changed as well as the camp's occupants. The New Zealanders also had a club, which was not on the camp. This was in Butts Green Road and is still standing and known as Wykeham House. A plaque commemorating its previous use by the New Zealand forces was fitted to the wall a few years ago.

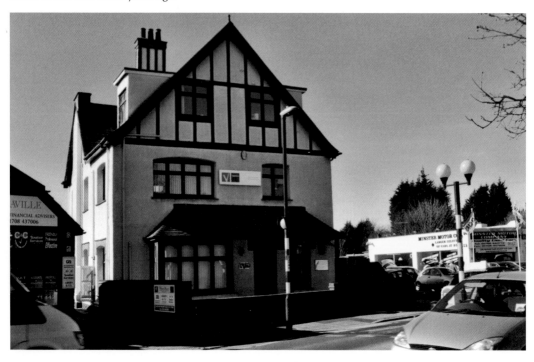

Hornchurch Village

The village was much more rural in the past and, as this old image shows, transport was more likely to have been by horse than by car. The modern image shows the High Road from Greytowers Avenue. The large building in the centre is now a bingo hall but was once the Tower cinema, named after the Greytowers Estate on which it was built.

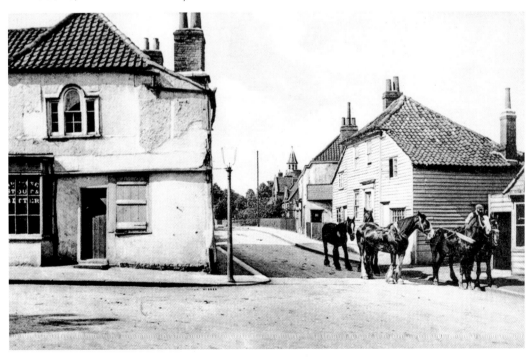

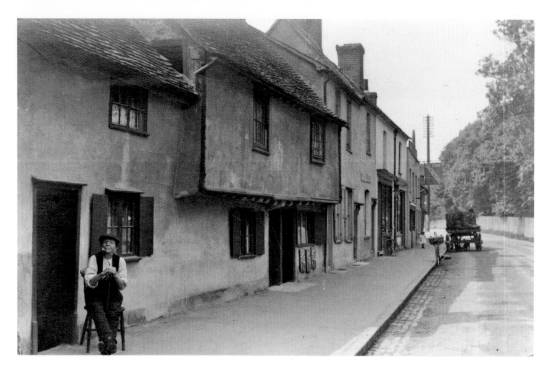

Hornchurch Village

Another old view of the village. Horse drawn transport can again be seen, as can a gentleman taking his leisure on a chair outside his house. Very few old buildings have survived in the High Street. The modern photograph shows that transport is no longer reliant on horses and is much more plentiful than in the past.

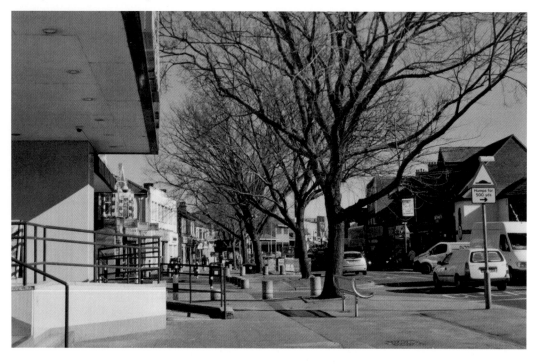

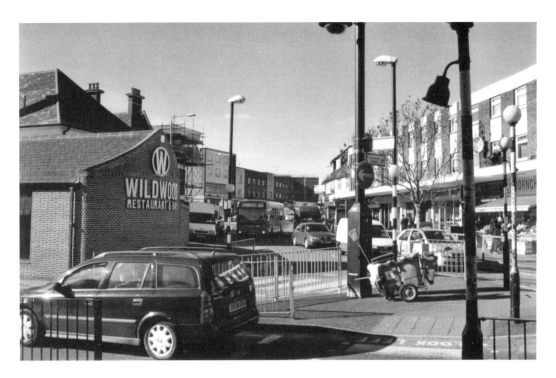

Hornchurch High Road

This old photograph of the High Road is taken from the White Hart and shows how narrow the road once was. The modern photograph is taken from the same place and shows what was the White Hart on the left. The old pub has gone through many changes, including being rebuilt in the 1930s. It has also undergone series of renaming and is now a restaurant.

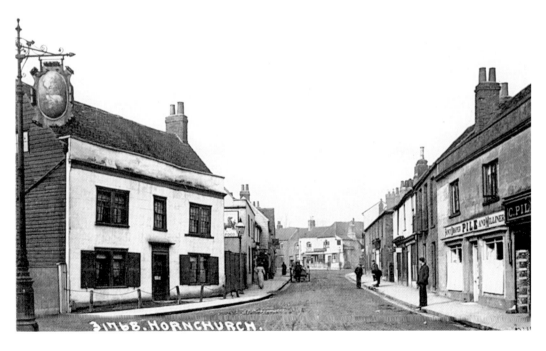

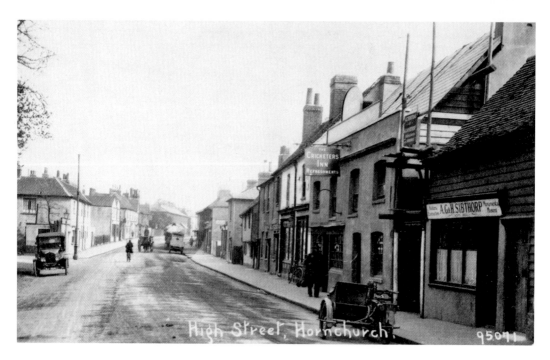

Hornchurch High Road

Another view of the High Road showing the old Cricketers Inn. There is now a more modern pub of the same name. There are also some early-motorised forms of transport in the image. The modern photograph shows some of the only remaining old buildings still standing in the High Street. The old cottages mainly date from the turn of the century so were probably modern compared with most of the old buildings in the previous photograph.

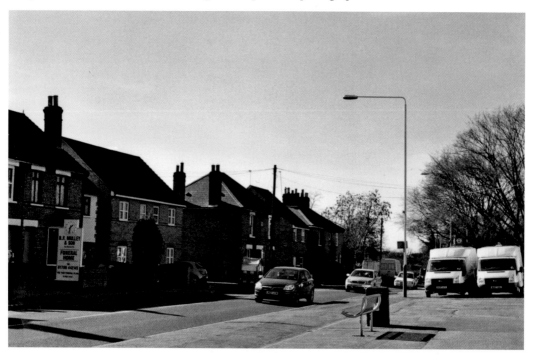

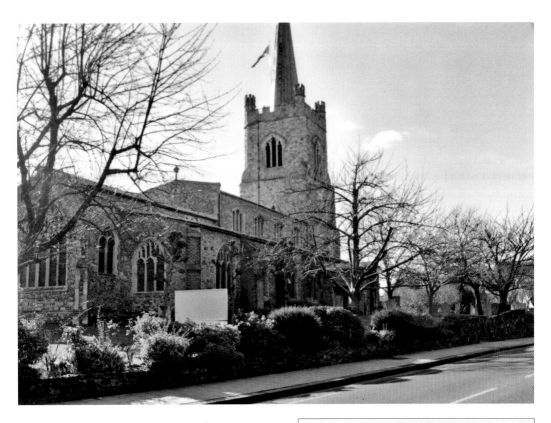

St Andrews Church

Originally dating from the eleventh century St Andrews was once the only church in Havering. The present building is not as old as that, although part of it does date from a few centuries after this. Little has changed apart from the wall surrounding the front of the church and the fact that the graveyard surrounding the church is now much larger and contains numerous graves of servicemen from both world wars.

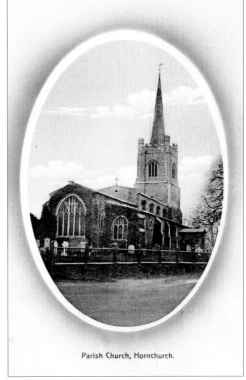

Parish Church, Hornchurch.

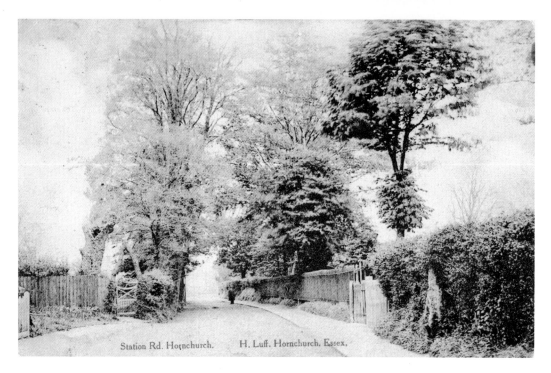

Station Rd. Hornchurch. H. Luff, Hornchurch, Essex,

Station Lane Hornchurch

The old image of Station Lane shows how rural it was in the not too recent past. The arrival of the railway was however one of the reasons for its change. The modern photograph is of the station from Suttons Lane and shows where Station Lane begins at the hill over the railway.

A Hornchurch Home in 1912

The old photograph shows what must have been a typical home for the well off local resident in the period just before the First World War. The address given on the rear of the card is Elmhurst, Hornchurch. Perhaps the house still exists. The modern photograph is of a house in Hornchurch today which would probably also be described as being a home of the well off variety. It is in fact one of the old buildings of the Cottage Home Estate. The old entrance to the home, now overgrown and unused, can still be seen.

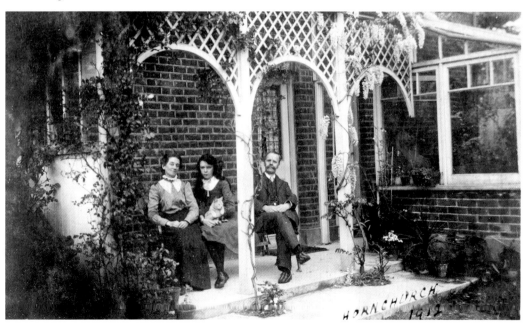

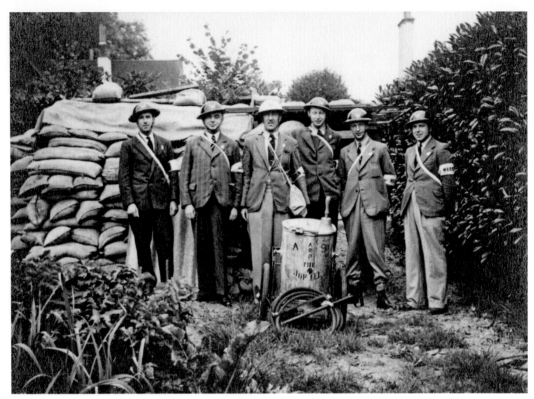

Hornchurch ARP Wardens
A group of ARP Wardens in Hornchurch
during the Second World War. This
was obviously taken before they were
given their uniforms. The reason that
Hornchurch was so often a target in
air raids was, of course, Sutton's Lane
airfield. This is one of the few remaining
buildings that survive and is the entrance
to one of the airfield's shelters. (*London
Borough of Havering Local Studies
Library*)

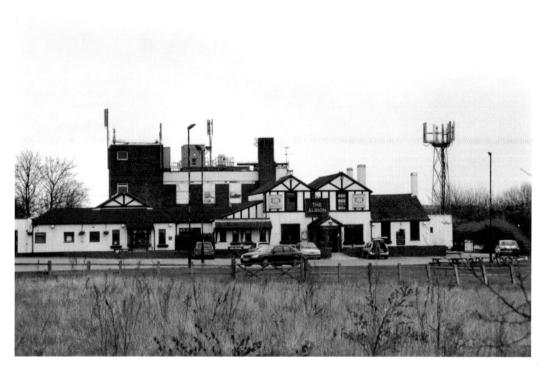

The Canteen Rainham

The Canteen Public House in Rainham, now known as the Albion, stands close to the roundabout at what was the old A13 – now the A1306. The extreme right hand part of the modern building looks as though it could be the original inn. It has obviously been greatly extended to the left.

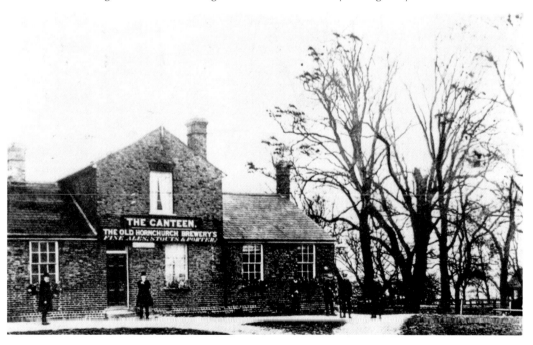

Dover's, Rainham

Dover farm has given its name to the area around the roundabout near Rainham Tesco. It is still known as Dover's Corner. The site of the farmhouse is now part of the La Salette Roman Catholic Church and school shown in the modern photograph.

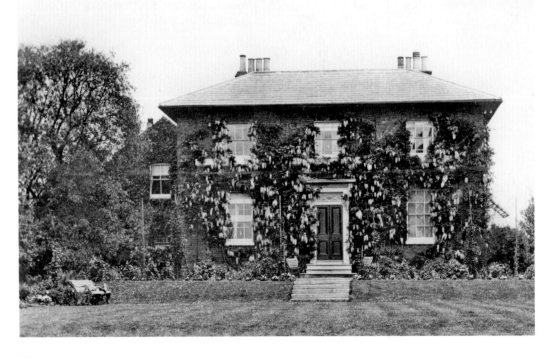

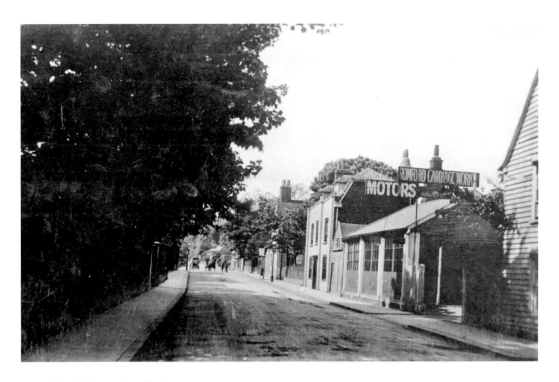

North Street Romford

A view of North Street in the early part of the twentieth century. Romford carriage works also deals with motorcars as the sign states. However the transport on the road in the distance seems to be horse powered. North Street has changed dramatically as the modern photograph shows. Apart from the Golden Lion on the left, little else remains of the old street.

Romford Baths

The old Romford baths in Mawney Road, shown here, was where many of the young people of Romford and surrounding areas learnt to swim, until they closed and were replaced with the Dolphin – a pool that had a much shorter life span than the old one. Offices were originally built on the site of the old pool but these were later replaced with the flats that now stand there.

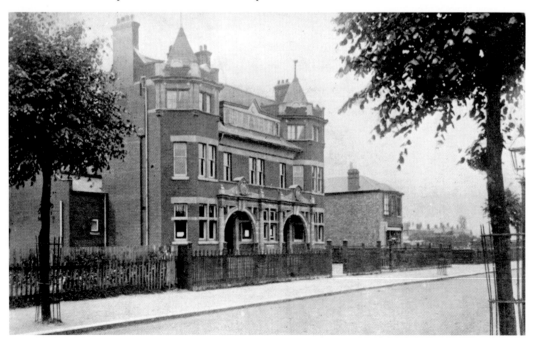

Lloyd roof insulation

saves £100 per week

Cuts capital spending, too

Since 1946 the roof of the Betterwear Products factory at Romford has been lined with ½" Lloyd Insulation Board fixed by the Lloyd Talon System. During these years, building extensions have almost doubled the floor area, yet the factory is still heated by the same plant using the same amount of coal as was needed before the expansion. Lloyd Insulation has saved heavy capital expenditure of more than £2,500 on extra heating plant and is regularly saving about £100 a week in winter fuel bills.

Increased comfort helps to increase output

Before insulation, this corrugated asbestos northlight building was very difficult to heat to 60°F in winter, while the summer temperature often rose to 92°. Now, extremes are ironed out and a comfortable working temperature is easily maintained throughout the year.

Yet another advantage of Lloyd Insulation is that dust, which formerly entered freely through eaves and ridge, is now trapped by the roof lining. It no longer falls on the operatives below or spoils their sometimes delicate work.

Full information about Lloyd Insulation and its applications are freely available from

BOWATERS BUILDING BOARDS LIMITED
HAREWOOD HOUSE, HANOVER SQUARE, LONDON, W.1 *MAYfair 9266*

A member of the Bowater Organisation

Betterwear

Part of North Street has always been industrialised. One of the larger factories in the area was the brush manufacturer Betterwear whose workforce seems to have been mainly female as the photograph shows. As with other large employers in Romford they no longer exist. The site in North Street is now a large Matalan store.

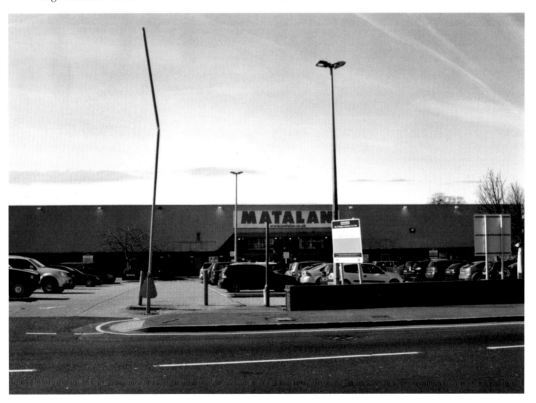

55

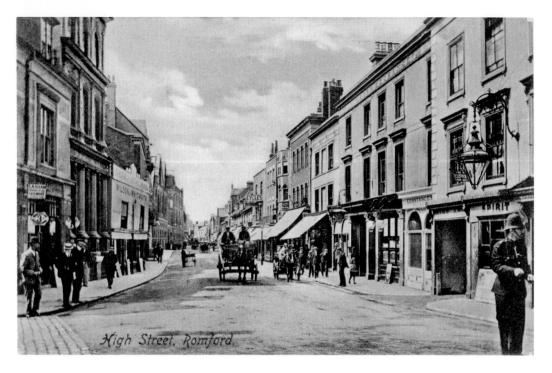

High Street, Romford.

High Street Romford

The High Street was, as can be seen in the old photograph, one of the more important shopping areas of the town in the past. The Golden Lion is on the extreme right of the image. Further down the street on the left is what looks like the brewery buildings. The modern photograph shows that few of the original buildings survive on the left side of the road.

High Street Romford

Another old photograph of the High Street. The building in the centre on the right would seem to be the old White Hart. Although this has gone through a number of name changes it is still recognisable as the same building. The modern view is taken from further along the road looking towards the market. The only old building that remains is the pub on the left, the white building, which has now closed down.

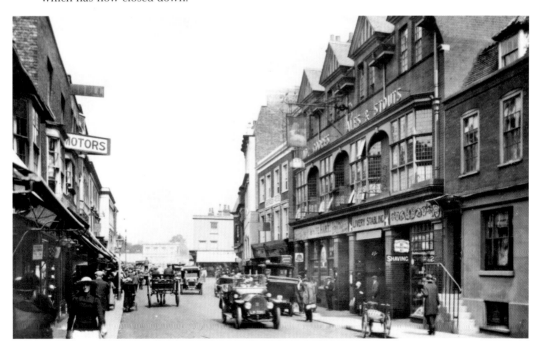

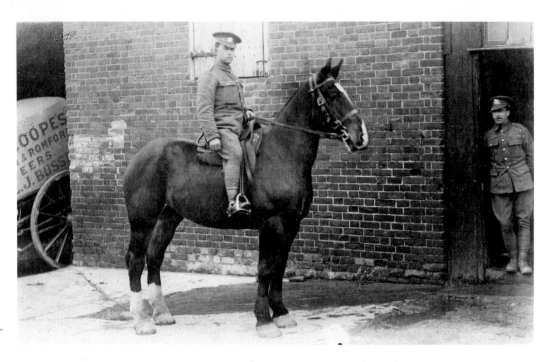

The Brewery

The dominant building in the High Street was the brewery. The old image shows two soldiers, one mounted and a Romford brewery cart to the left. The modern view is of an old entrance to the brewery, now the entrance to the Brewery Shopping Centre.

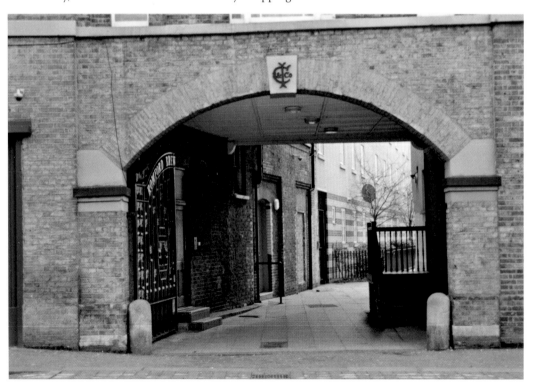

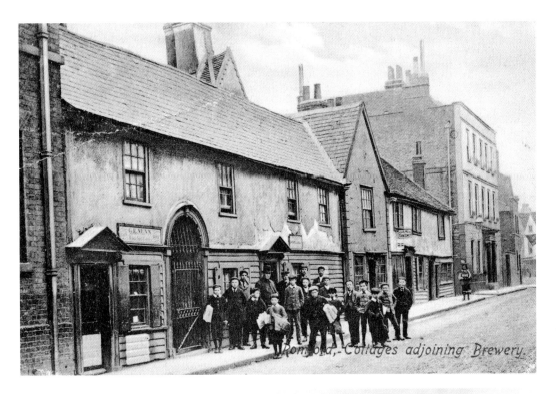

Thom old,—Cottages adjoining Brewery.

The Brewery

The old image shows cottages that
adjoined the brewery in the High
Street. Perhaps the crowd of people
outside were the residents of the
cottages or workers from the Brewery.
A memento of the Brewery is the
large old copper vessel that now
stands at the road entrance to the
Brewery Shopping Centre car park.

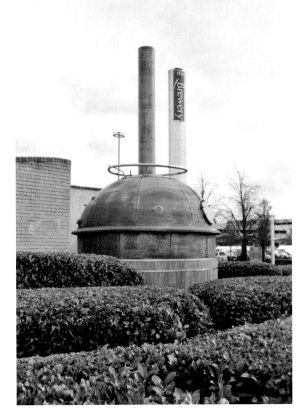

Mashiters Chase

An old view of Mashiters Chase which was at the time very rural, the photographer has caught the attention of some young Romford inhabitants. According to the card the Chase became Junction Road. Today, the road is far from rural. Some older houses remain, but many of the homes are more recent. The back of the Liberty Car Park is also next to the flats on the left of the photograph.

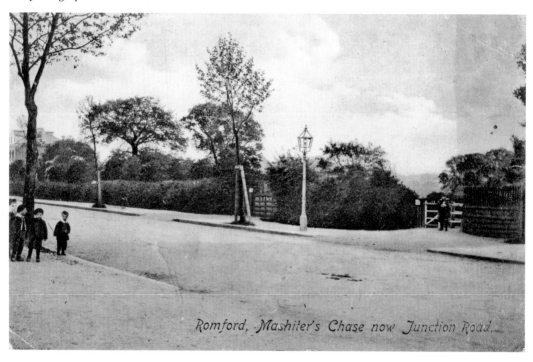

Romford, Mashiter's Chase now Junction Road.

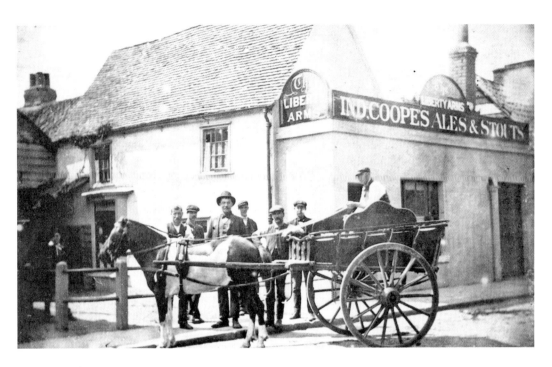

The Liberty Arms

The old photograph shows the Liberty Arms public house, which stood in Waterloo Road at the turn of the twentieth century. Transport to the pub was obviously horse powered. Although on a different site, the much more recent public house, hotel and restaurant shares part of the name and is called the Liberty Bell. It stands on the Romford Ring Road on the corner of Western Road.

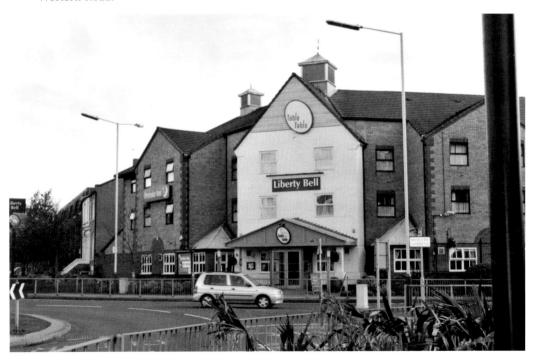

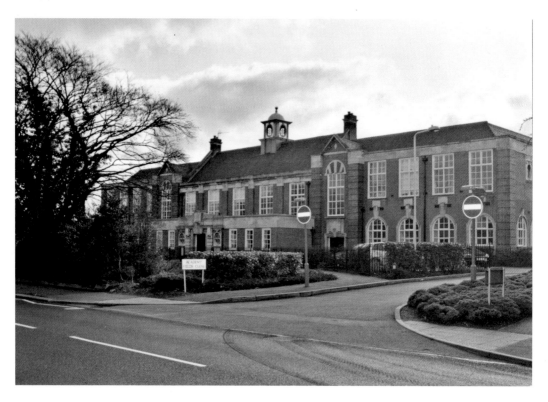

Romford County High School For Girls

The County High School for girls was opened in 1910 in Heath Park Road. It later became part of Frances Bardsley School, which had another building in Brentwood Road. This part of the school in Heath Park Road was closed and has become private residences.

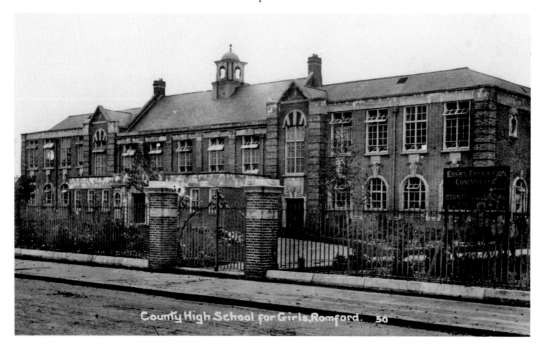

County High School for Girls, Romford. 50

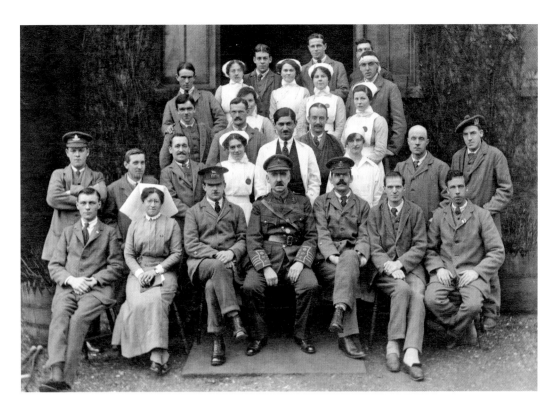

Wartime Hospitals

During the First World War a number of large houses were turned into hospitals for wounded soldiers. This one was in Romford, but unfortunately I don't know where. There was another hospital in the area for soldiers suffering from shell-shock. However I am again not sure where as records of these temporary hospitals were not well kept. Using large houses for medical uses has not entirely stopped as the Main Road clinic shows.

Freedom of the Borough

After the Second World War the Essex Regiment was awarded the freedom of the borough. The ceremony took place in Laurie Square where the war memorial stood and which was surrounded by a number of large houses. Laurie Square unfortunately vanished when the Ring Road was built and the site is now occupied by the roundabout and the library. The war memorial was moved along to the other side of the town hall. (Below: *London Borough of Havering Local Studies Library*)

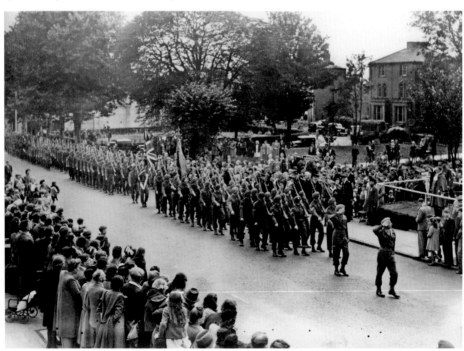

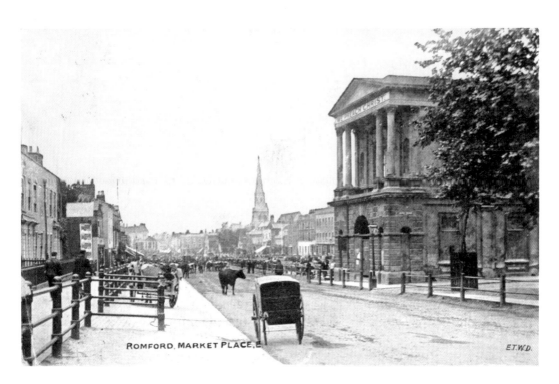

ROMFORD. MARKET PLACE, E.

E.T.W.D.

Romford Market

A very old view of the market from the east. It shows the old Laurie Hall on the right and the church further along. Very few of the buildings in the photograph are still there. The modern photograph is taken from roughly the same position. A large roundabout on the ring road covers the area where Laurie Hall would have been with a very recent new building across the present end of the market.

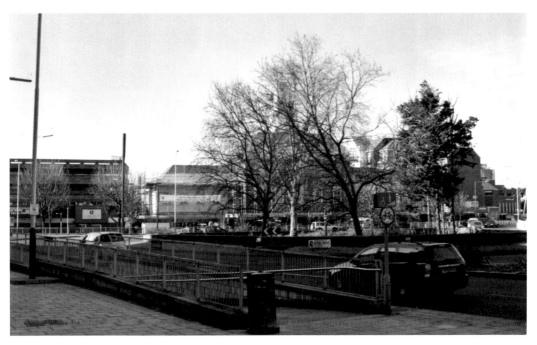

Romford Market

This old image shows the west side of Laurie Hall, which stood at one end of the market, and the old toll gate – which also stood at the end of the market – where the road ran through the market place and carried on up towards Gallows Corner. The recent image shows the new building that has been built across the end of the market place in a similar position to where the old Laurie Hall used to be. The subway is now under the building to the right.

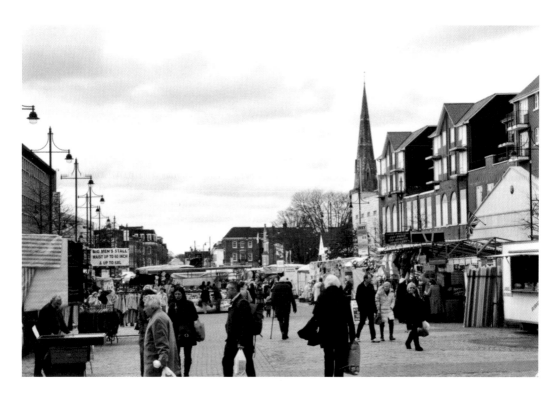

Romford Market

Another old view of the market from the days when livestock was still sold there. On the far left is a bus from when a route ran through the middle of the market along with normal traffic. The market today has no livestock for sale and the goods that are available would have been strange to the customers in the old market. There are more modern buildings on the left which have replaced the old Romford Shopping Hall.

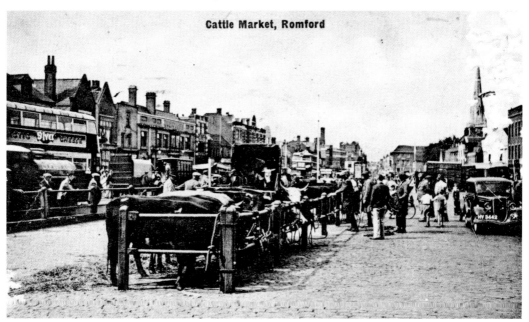

Cattle Market, Romford

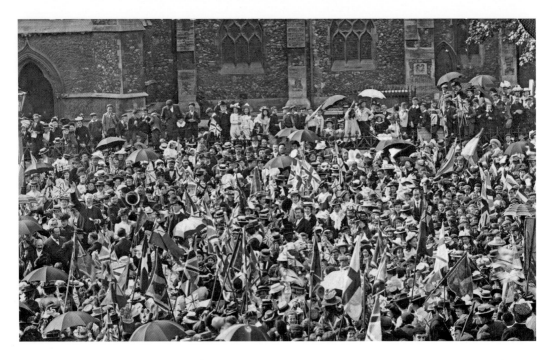

An Unusual Event In The Market Place.

In 1900 the Boer War was being fought in South Africa. The Boers had besieged the town of Mafeking and the relief of the town in May that year was received with rapturous joy back in England. The crowd depicted turned out in Romford Market Place to celebrate showing, perhaps, that the people felt more in tune with the conflicts being fought by the country's forces. The modern photograph shows the end of the church, visible in the old photograph, and the church house – one of the old buildings in the market place that has survived.

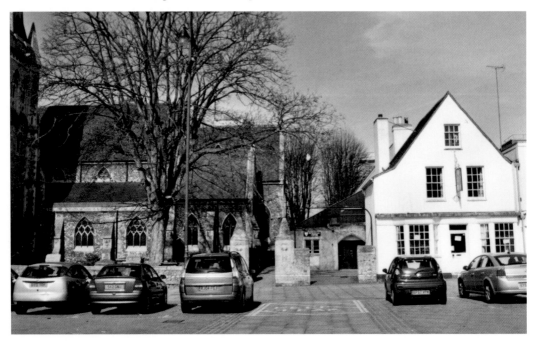

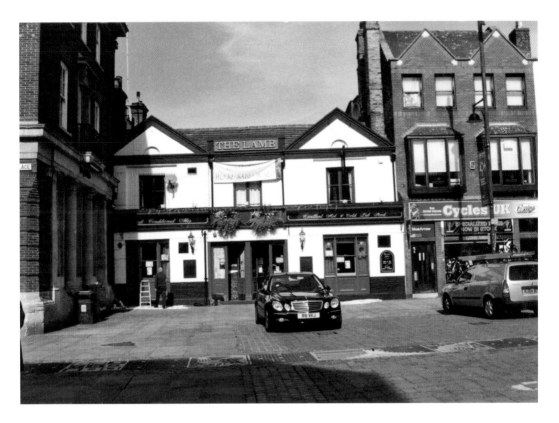

The Lamb

The old illustration shows the Lamb public house in the Market Place. The building dates from the early nineteenth century. As the modern photograph shows, the building has changed little in this time. It is worth noting that of the old buildings that have survived in the town of Romford, the majority seem to be public houses.

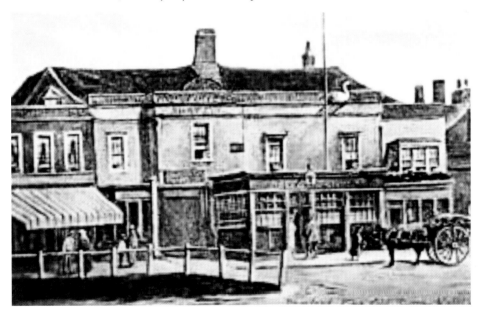

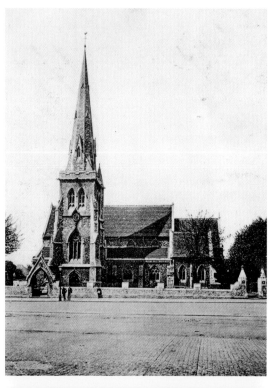

The Church

The church of St Edward the Confessor stands in the market place and is one of the oldest surviving buildings. However it is not as old as it seems and dates from the mid- nineteenth century, replacing an older church that fell into disrepair. As the modern image shows, the church has changed little since the old photograph was taken except for the area outside now being used as a car park when the market is not being held.

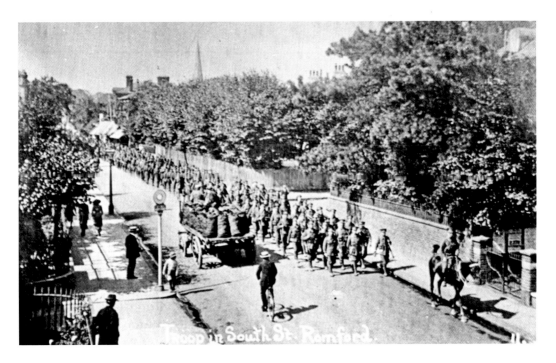

South Street

During the First World War there were a number of soldiers billeted in the town. This group are marching along South Street and there are houses rather than shops along the roadway. A modern view of South Street, taken from where the ring road crosses it, shows the few older houses that still stand in the road. Apart from this block everything else in the road seems to be from a much later period. (Above: *London Borough of Havering Local Studies Library*)

South Street

This view of South Street shows how narrow the road previously was. The banner advertising a grand summer fête does not seem to have to stretch far between the buildings. The modern view shows how much wider the street seems to have become. It is difficult to see any similarities between the two images.

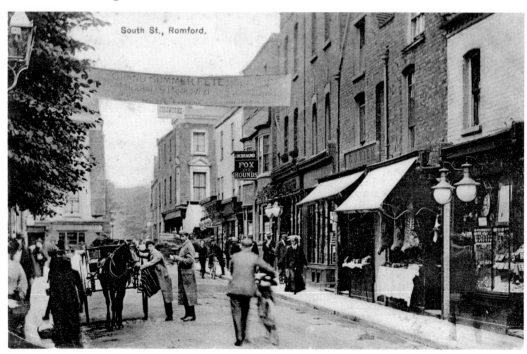

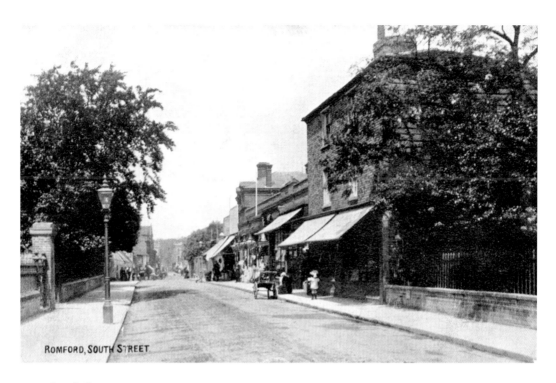

ROMFORD, SOUTH STREET.

South Street

This view of South Street shows the end of the shops and railings of the front of what were large houses. There are trees lining the road, which have entirely vanished from South Street today. The modern photograph of the end of the shops shows not houses but a large gym and smaller houses opposite that have shop premises on their ground floors.

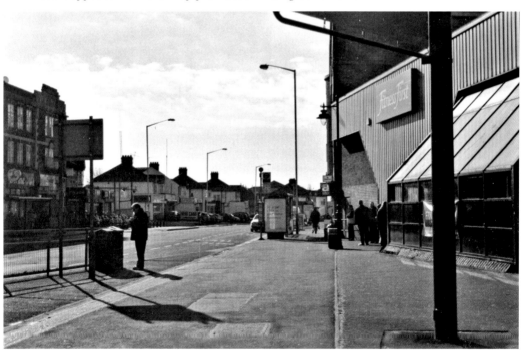

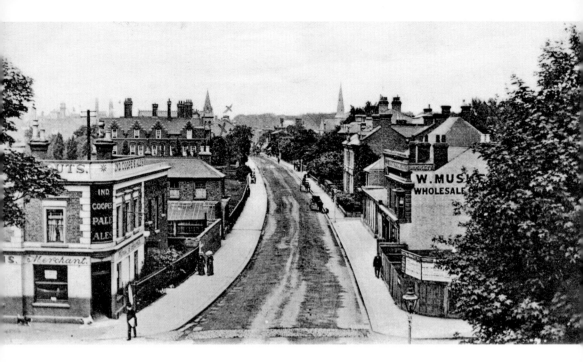

South Street

This photograph of South Street is looking towards the market, with the church spire of St Edwards to the right of centre. It must have been taken from where the station stands as there is no sign of the rail bridge across the road. The modern image shows almost all recent buildings apart from the block on the left which appear to be older.

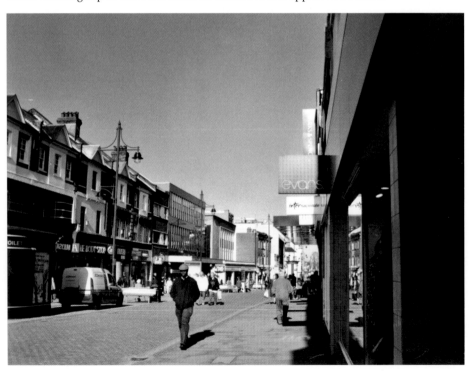

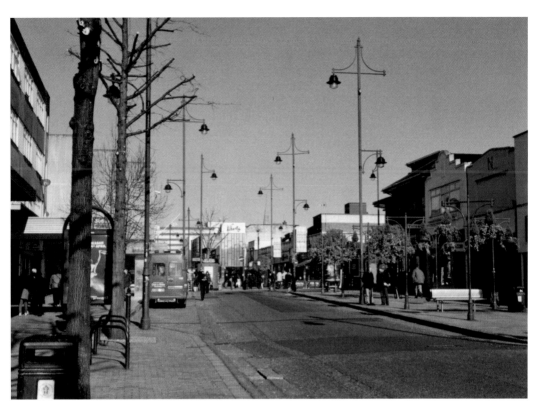

South Street

The Congregational Church stood in South Street and burnt down in 1883. A new one was built immediately and lasted until 1965 when it was sold and a new church built in Western Road. I had a problem finding where the old church stood but there is a spire visible on the previous old image towards the end of South Street on the left. The next old image of the Post Office shows a wall next to it very similar to the wall of the church. I suspect that it stood close to where the road now turns into Western Road.

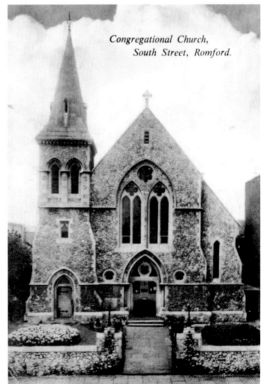

Congregational Church,
South Street, Romford.

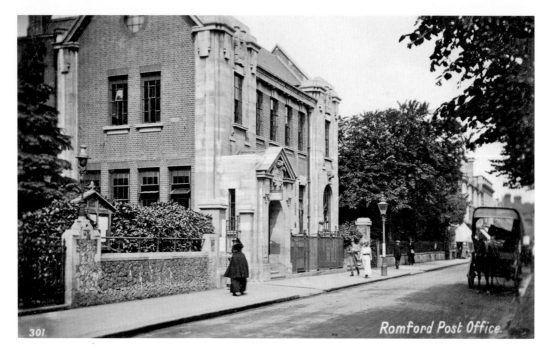

Romford Post Office.

The Post Office

The post office in South Street had a long history. This view dates from the First World War. I can personally remember the post office up until the 1960s when it retained the large official government building look that post offices used to have. The building still survives but, like so many other old buildings in Romford, it is now a nightclub.

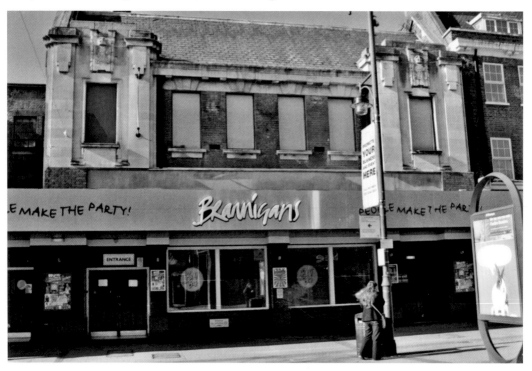

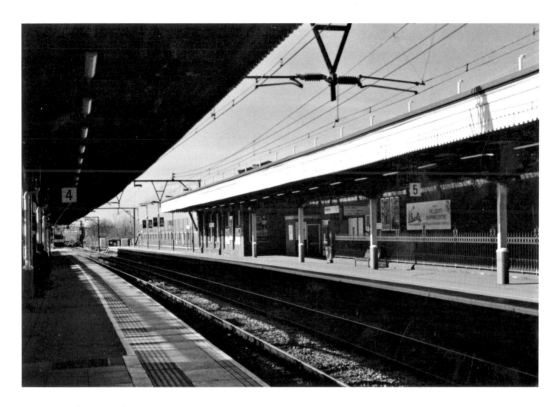

Romford Station

The old view of Romford station shows how busy it was in the past. There seems to be only two platforms for the old steam trains to stop at. Although the modern view seems to show the station as being very quiet this was taken outside the rush hour and just after a train had left. The overhead wires show that the trains are no longer powered by steam.

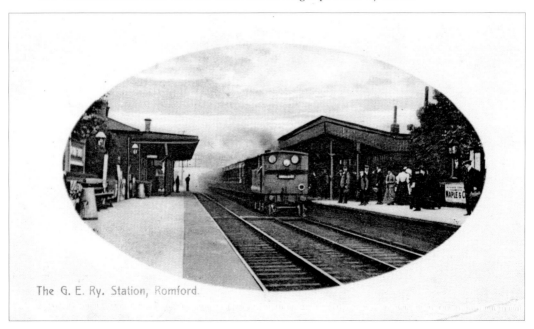

The G. E. Ry. Station, Romford.

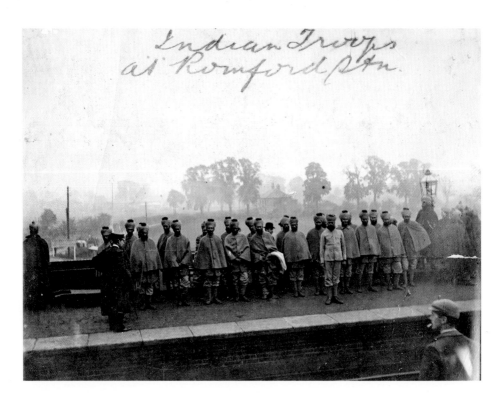

Soldiers At The Station

This old view shows a group of Sikh soldiers at Romford Station during the First World War. Although there were a number of units based in the town at the time I have been unable to find any record of Indian troops being based there. It may well be the case that they were on a visit. It is interesting to note how the view above the station wall has changed from that period to today. (Above: *London Borough of Havering Local Studies Library*)

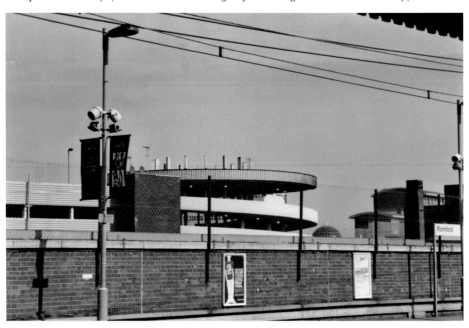

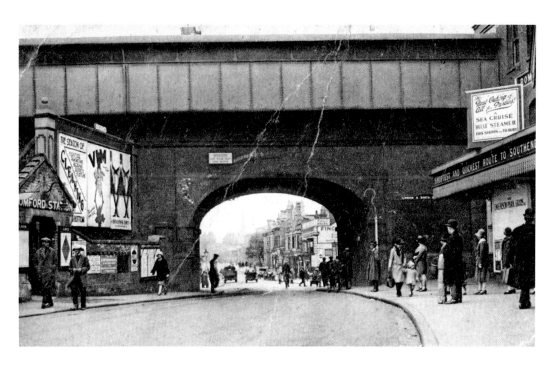

The Railway Bridge

The old view of the railway bridge at Romford shows how narrow the road was then. The entrance used to be on the right but this photograph shows entrances on both sides of the road. The station entrance is however now only on the left. The modern bridge has a much wider space for traffic to pass through and is also high enough to allow double decker buses to pass under it.

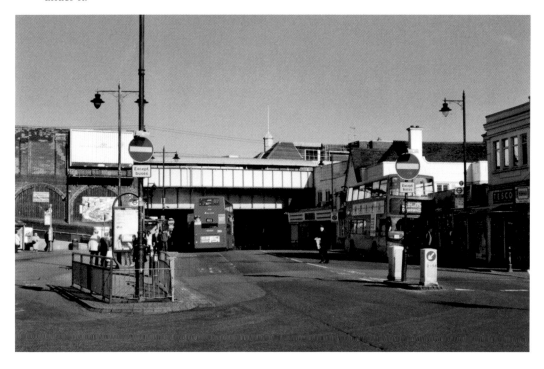

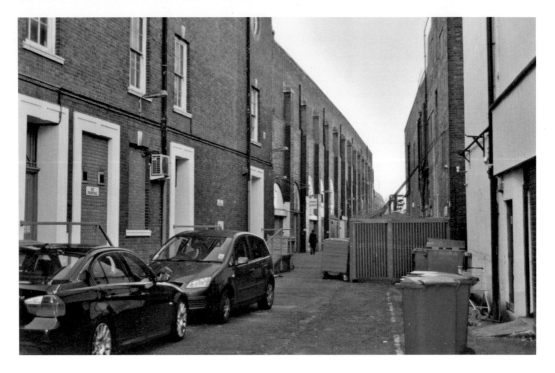

Station Approach

When the station was first built at Romford there was an open embankment alongside it. This was obviously where both horse and motor cabs waited for their fares as they got off the trains. The side of the station is now built up to hold the platforms. The alleyway at the side of the station is the Batis, which ran between the station and the brewery.

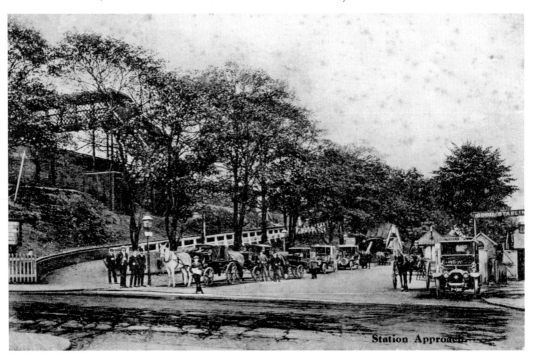

Station Approach.

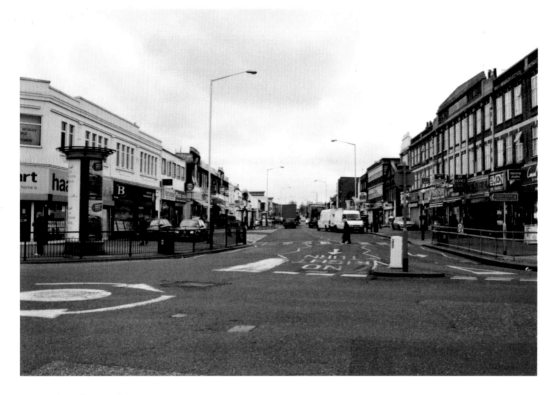

Victoria Road

Victoria Road was one of the more built up areas of the town from an early age. It was however mainly residential, with only some industry. There are still a number of older houses, as the road gets further away from South Street. As the modern photograph shows, the first part of Victoria Road – where it meets South Street – is now all shops.

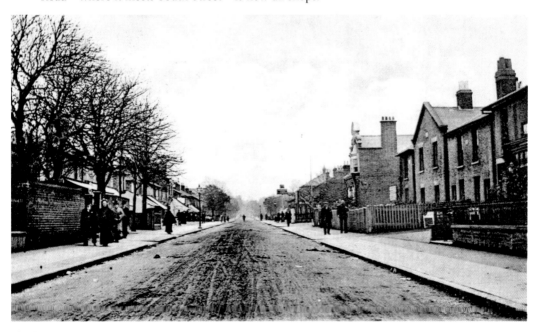

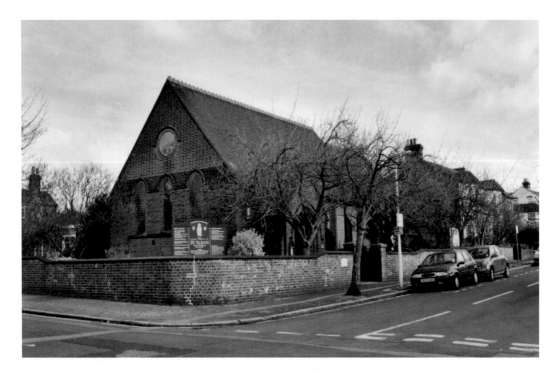

St Alban's Church

The church in King's Road was opened as a mission of St Andrews in Hornchurch in the late nineteenth century. This image dates from the early twentieth century. It did not become a separate parish until after the Second World War. The actual building seems to have changed little today, although the cross has vanished from the roof.

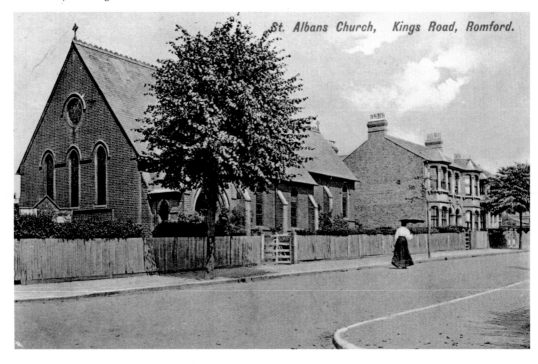

St. Albans Church, Kings Road, Romford.

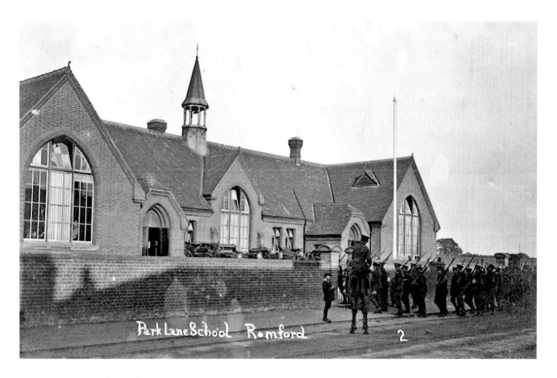

Park Lane School

The old photograph shows the soldiers who were based at Park Lane School during the First World War. A number of local schools were put to this use. The building is still used for educating children but is now the Raphael Independent School and is a private fee paying establishment. (Above: *London Borough of Havering Local Studies Library*)

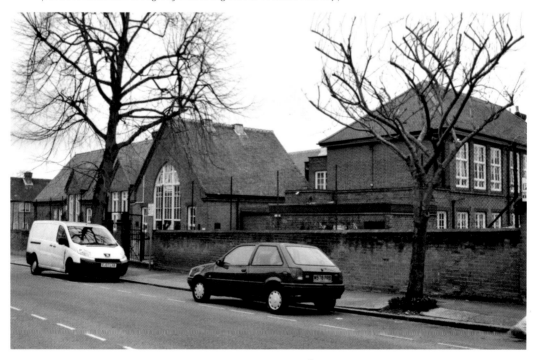

The Coopers Arms

The old photograph shows the Coopers Arms public house in Rush Green in the early part of the century. It was still known as the Coopers Arms in the 1970s but the building has changed dramatically. Since the 1970s the pub has undergone several name changes and is now known as The Havering Well after being the Rush Green Tavern for a time.

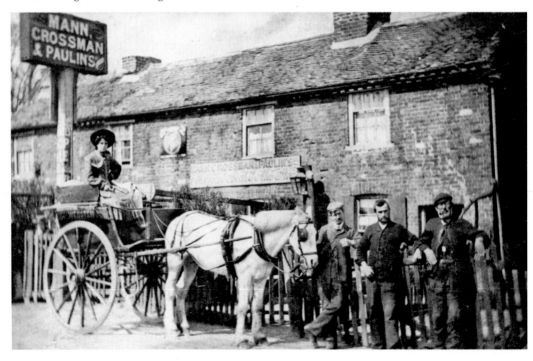

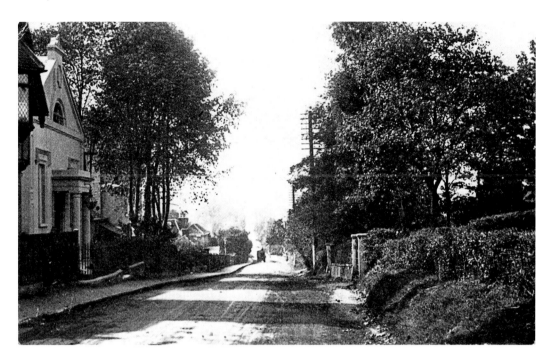

The Chapel

The old chapel on the left of the photograph was obviously in a rural position when this photograph was taken early in the twentieth century. The chapel is much older and was built in 1800.There is little to see looking down the hill towards Hornchurch. The view is very different today with the town of Hornchurch spread out in the distance and the spire of St Andrews clear above the houses.

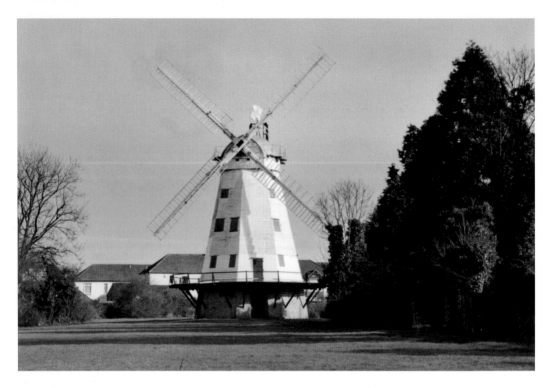

The Upminster Mill

Although there were a number of mills in the area, Upminster is the only surviving example. It dates from 1802. Although the mill has changed little since this old image was taken the surroundings have. The old house and buildings behind the mill have now been replaced with a more modern housing estate. The mill is now open to the public at certain times.

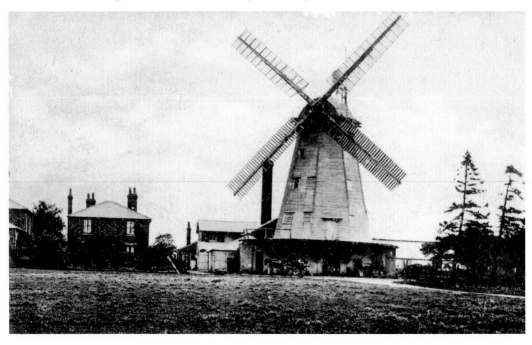

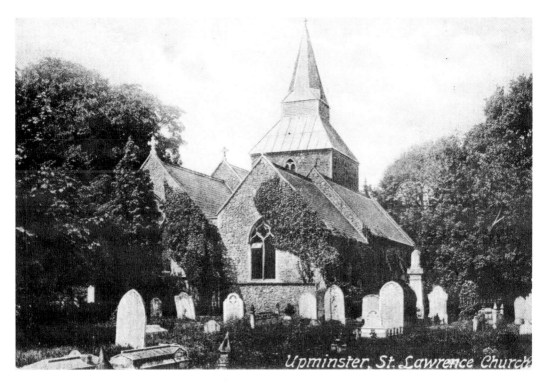

Upminster, St. Lawrence Church

The Church

The Church of St Lawrence stands on the corner of St Mary's Lane and Corbets Tey Road. The Upminster war memorial stands at the front of the church. The Church has changed little since the older photograph was taken.

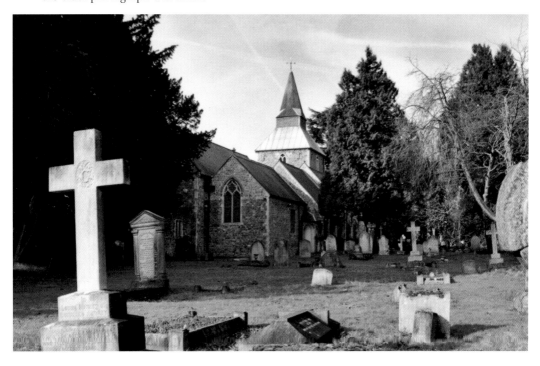

Gaynes Estate

The Gaynes Manor Estate was one of the large estates that existed in the area. The estate has been built on since then and is now covered with modern housing. The recent image shows some of the more modern housing in the area and an old cottage that dates back to the time of the Gaynes Estate.

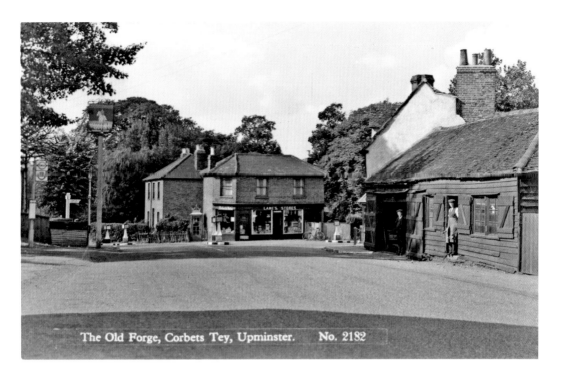

The Old Forge, Corbets Tey, Upminster. No. 2182

Corbets Tey

The village of Corbets Tey is shown in this old photograph with its old forge on the right. Although Upminster has now spread to include Corbets Tey, the area still retains its small village atmosphere, as this modern view shows.

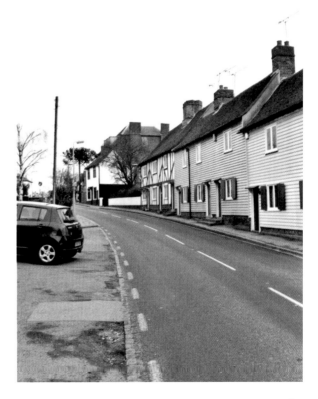

Upminster School

The older view shows Upminster School in the early twentieth century. There were, no doubt, fewer pupils in those days. The present Upminster School is much larger and has a much-increased population to deal with now that the area has grown so much since the earlier view. (Below: *London Borough of Havering Local Studies Library*)

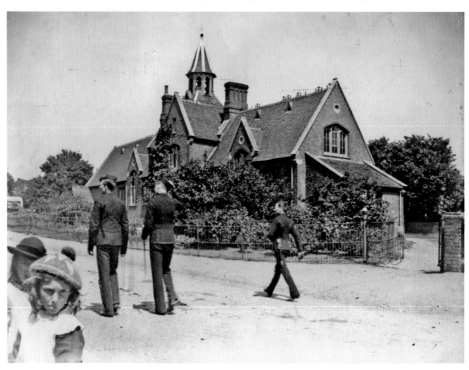

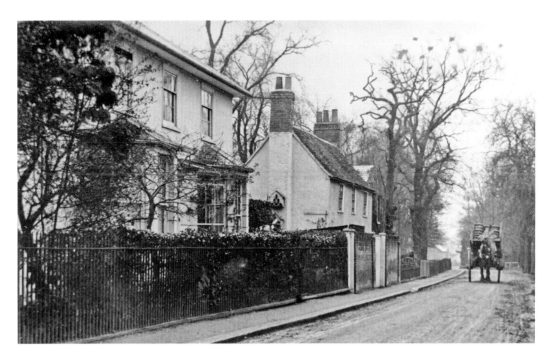

Cranham Road

The older view is marked Cranham Road, Upminster. This was a problem as the only Cranham Road I could find in the area was in Romford. I was then told however that St Mary's Lane was known locally as Cranham Road. The modern view is much more built up but some of the houses could date from the older view.

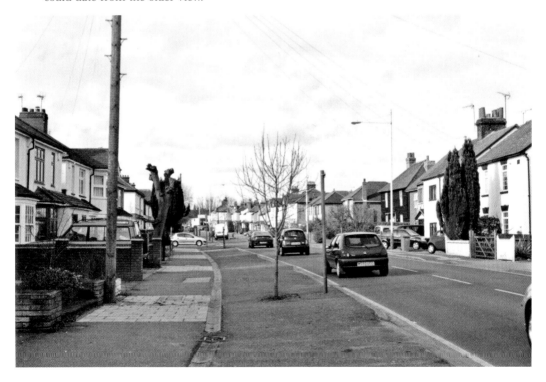

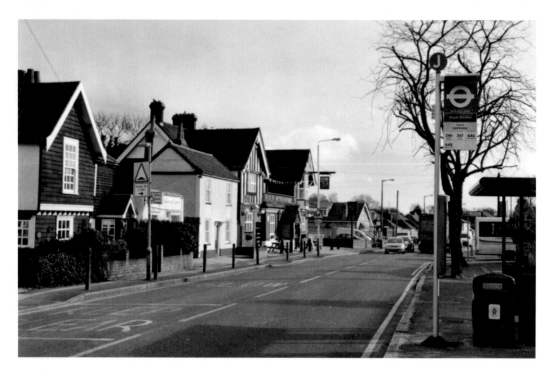

Cranham Road

As with the previous image the Cranham Road label on the photograph was a mystery. The public house in the photograph confirmed what I had been told. The Masons Arms still exists and as can be seen from the modern image is actually in St Mary's Lane.

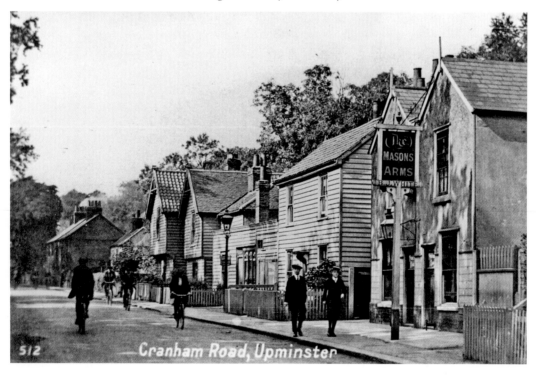

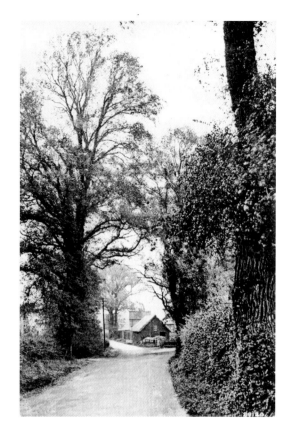

Hall Lane

Hall Lane, Upminster. At the turn of the century this was no more than a rural lane as can be seen from the earlier photograph. The modern Hall Lane is much more built up and is now a very busy road. It is lined with some very large houses.

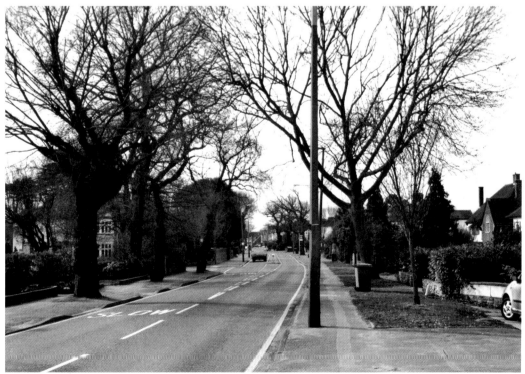

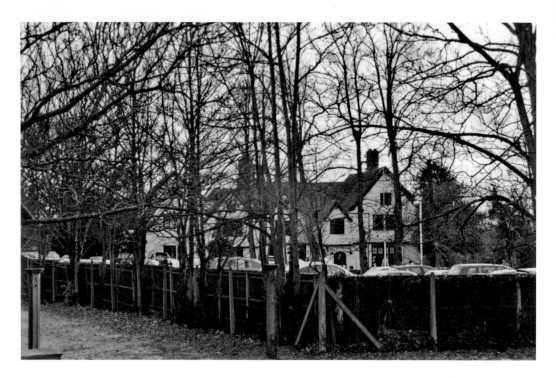

Upminster Hall

Hall Lane may have been a rural road, but it led to a grand house that dated back to the fifteenth century. Upminster Hall has changed over the years and since 1927 has been part of the Upminster golf course. The Hall today is fenced off from the road and is open to members of the golf club. It also stands next to the old barn museum.

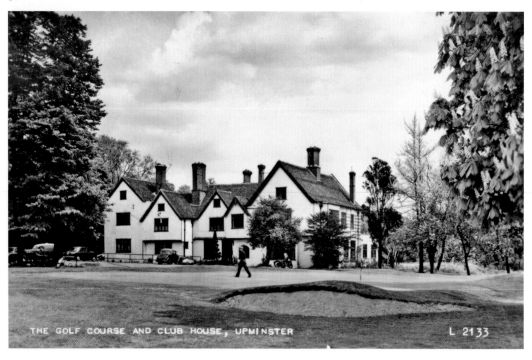

THE GOLF COURSE AND CLUB HOUSE, UPMINSTER L 2133

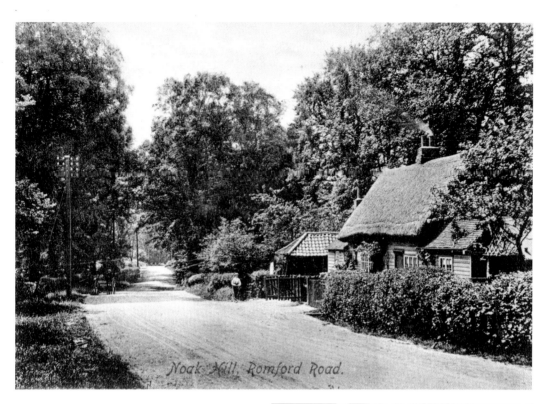

Noak Hill

Noak Hill in the old photograph is a small village which the expanding borough of Havering was yet to reach. The title on the old card states Romford Road Noak Hill but no road of this name now seems to exist in the area. The modern view is of Noak Hill Road and the old Bear public house. Although this still looks very rural, behind the position from which the photograph was taken is a large housing estate that reaches back to Harold Hill.

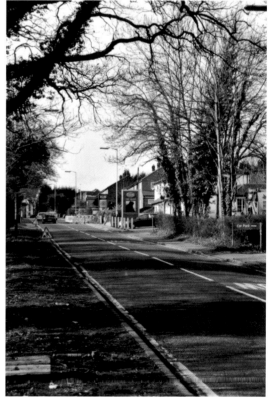

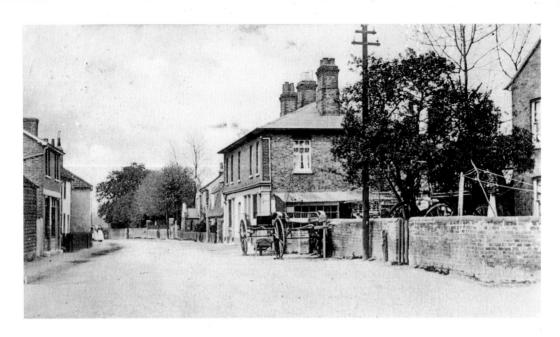

South Ockendon

It may seem strange that I have included a photograph of South Ockendon, which is in Thurrock. However North Road, as it runs towards Havering, becomes Ockendon Road at the border between the two boroughs. The modern photograph shows the border of Havering, the Thurrock sign in the image is the end of Havering and the beginning of the North Road in the old photograph. It is fitting that the final image in the book should show the limit of the borough.

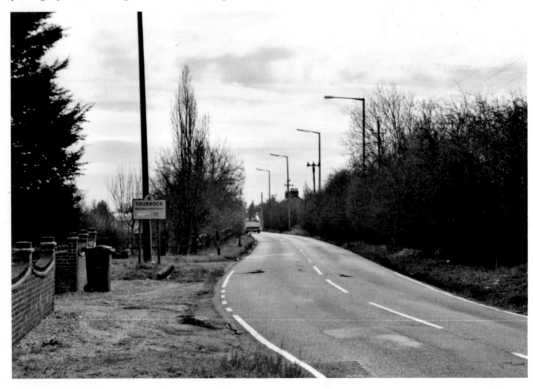